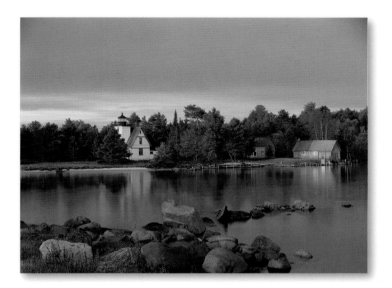

Christmas 2013

Katie,

Merry Christmas! Thank you for all you
did this year, you made a difference. Best
Wishes for a wonderful New Year!
God Bless
M.J. Jravanzo

MICHIGAN

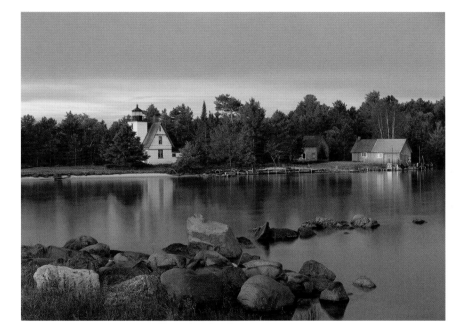

whitecap

The information in this book is true and complete to the best of the author's knowledge. All recommendations are made
without guarantee on the part of the author or Whitecap Books Ltd. The author and publisher disclaim any liability in
connection with the use of this information. For additional information please contact Whitecap Books Ltd., at 351 Lynn
Avenue, North Vancouver, British Columbia, Canada V7J 2C4.

Text by Tanya Lloyd Kyi
Edited by Elaine Jones
Photo editing by Tanya Lloyd Kyi
Proofread by Lisa Collins
Cover and interior design by Steve Penner
Interior layout by Roberta Batchelor
Front cover photograph by Bob Firth/First Light
Back cover photograph by Mary Liz Austin

Printed and bound in China

Library and Archives Canada Cataloguing in Publication

Lloyd, Tanya, 1973–
 Michigan
 (America series)

 ISBN 1-55285-114-1 (hardcover) — ISBN 1-55285-773-5 (paperback)
 ISBN 978-1-55285-114-2 (hardcover) — ISBN 978-1-55285-773-1 (paperback)

 1. Michigan—Pictorial works. I. Title. II. Series: Lloyd, Tanya, 1973– America series.

F567.L66 2000 977.4'044'0222 C00-0911070-4

The publisher acknowledges the financial support of the Government of Canada through the Canada Book Fund (CBF)
and the province of British Columbia through the Book Publishing Tax Credit.

For more information on the America series and other Whitecap Books titles, please visit our website at www.whitecap.ca.

There are hundreds of lighthouses on Michigan's shores, marking treacherous reefs and shoals in lakes Huron, Superior, and Michigan. For almost a century, since the first beacons were built in the 1820s, each outpost was maintained by a lighthouse keeper, rugged men whose solitary lives were punctuated only by storms. Often, their wives would accompany them to these remote peninsulas or tiny islands, spending months alone. They would tend farm animals, garden, and bear children, with only occasional visits from local fishers.

Since the early 1900s, the beacons have gradually become automated, but the romance they represent remains. Stories of fierce storms, breaking pack ice that could carry an unsuspecting keeper onto the Great Lake waters, and shipwrecks just out of reach draw today's visitors into restored beacons and homes, hoping for glimpses of the adventurous past.

Lighthouses aren't the only places where Michigan's history springs to life. Copper mines dot the Upper Peninsula, reminding sightseers of the region's boomtown days. Ramshackle sawmills still lie in forest groves, remnants of the 19th century. In the rugged wilderness of Isle Royale National Park or Huron-Manistee National Forest, there are reminders of the natives, fur traders, and settlers who passed this way hundreds or thousands of years ago.

In Detroit, there is evidence of a different kind of history—the history of invention. In 1879, young Henry Ford made his way here from his family farm in Dearborn, more interested in being a machinist than a farmer. By 1896, he had built his first automobile, the Quadricycle. His Model A appeared on the market in 1903.

In Michigan today, among Detroit's towering skyscrapers or at summer resorts along the Great Lakes, these times of adventure and invention may seem far away. But while the photos show a thriving present, they also reveal glimpses of untouched shores, looking much as they would have to the lighthouse keepers long ago.

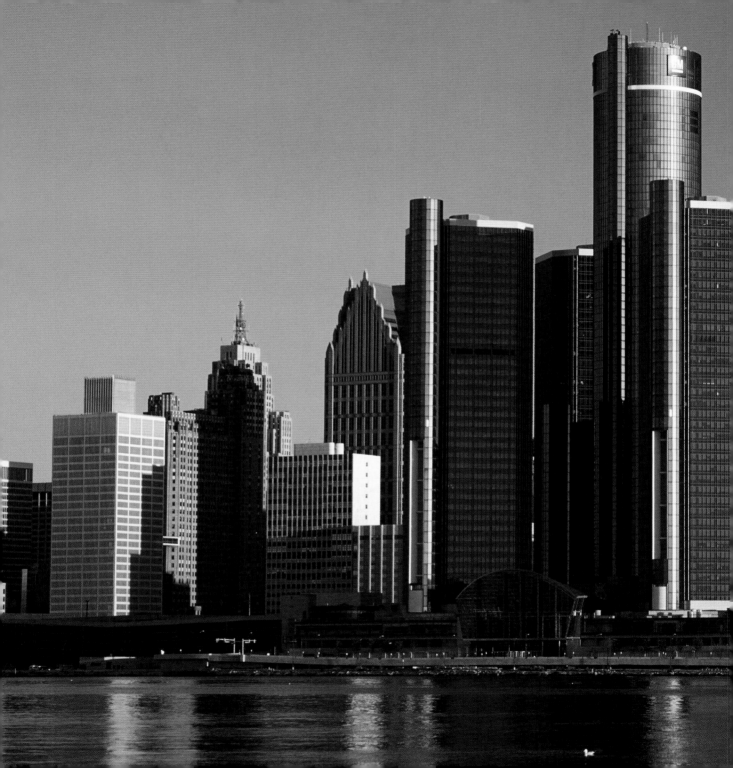

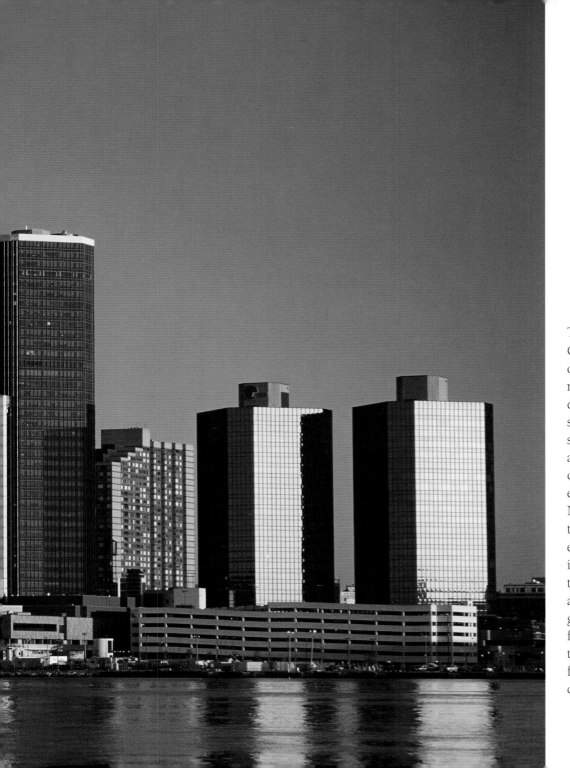

The Renaissance Center, a group of seven interconnected skyscrapers, dominates Detroit's skyline. Built in stages between 1976 and 1981, it is one of the world's largest office complexes. Now owned by GM, the buildings were extensively renovated in 2004, an overhaul that included the addition of a lighted glass walkway and a five-story atrium that provides riverfront access to the complex.

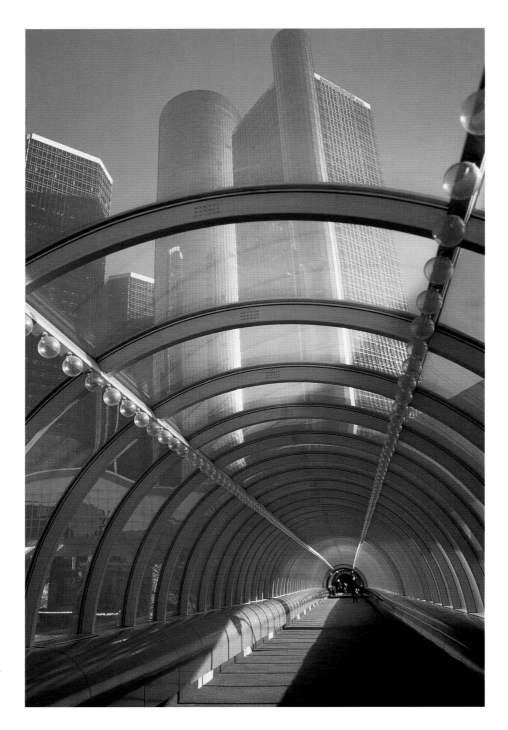

True to its reputation as the world's automotive capital, Detroit installed the first traffic light in the United States in 1915. The nation's first mile of paved concrete road was completed here in 1909. This walkway at Renaissance Center eases the flow of foot traffic around the complex.

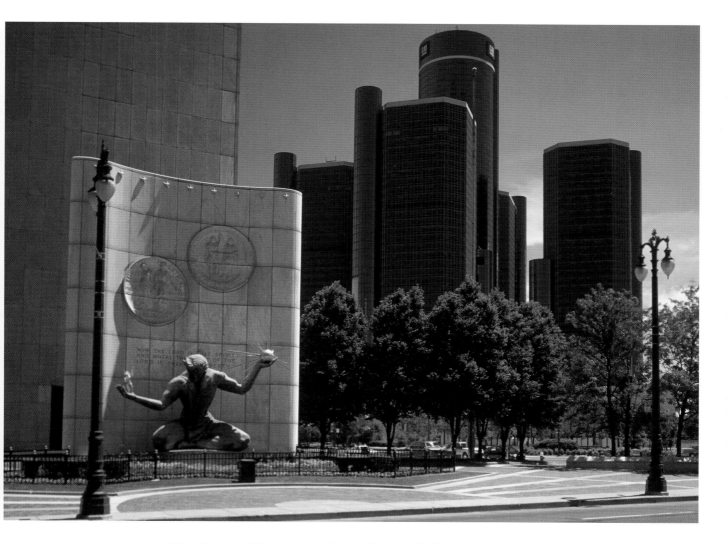

The "Spirit of Detroit" sculpture by Marshall Fredericks welcomes visitors to the Coleman A. Young Municipal Center. The 26-foot-tall bronze monument has become an easily recognizable symbol of the city. The inscription behind the statue reads, "Now the Lord is that Spirit: and where the Spirit of the Lord is, there is liberty."

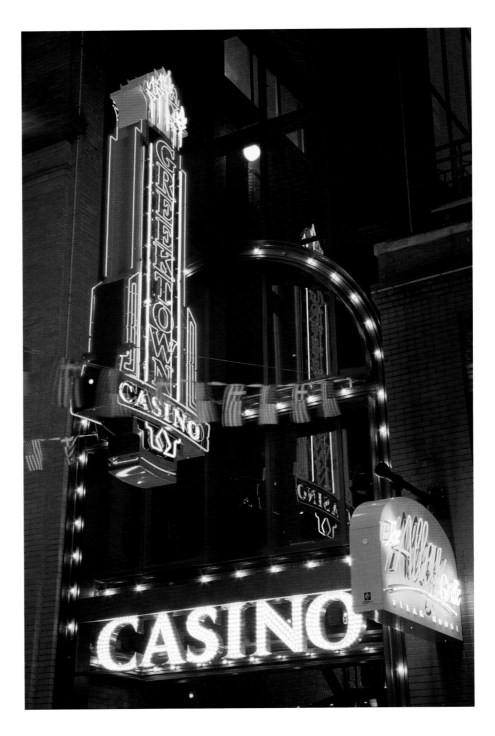

With eight blocks of vibrant restaurants, shops and nightclubs, Greektown is at the center of Detroit's nightlife. Late into the evening, the streets here are bustling with both visitors and locals.

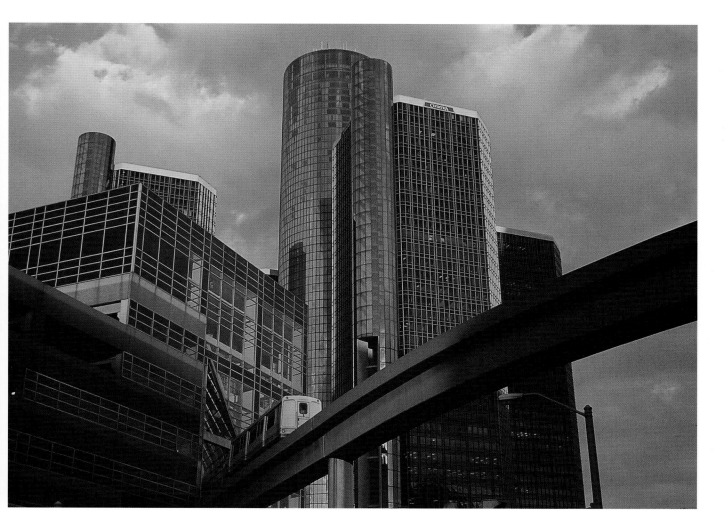

Detroit's People Mover whisks commuters and visitors around the city, with trains running every three to four minutes during rush hours. Because of the cold winters, the elevated tracks are equipped with specially designed heating coils to melt the snow.

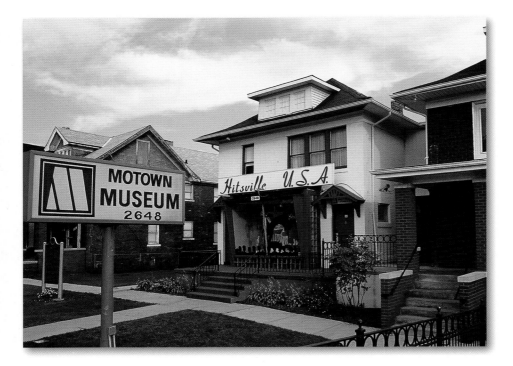

Hitsville, U.S.A., looks much as it did in the 1960s, when Detroit was the birthplace of Motown Records, the company that reinvented the music industry with its famous "Motown Sound." Today, the original Hitsville office is home to the Motown Historical Museum.

This giant fist celebrates the achievements of boxer Joe Louis. One of the city's most famous residents, he was the world heavyweight champion from 1937 to 1949, the longest reign in the sport's history.

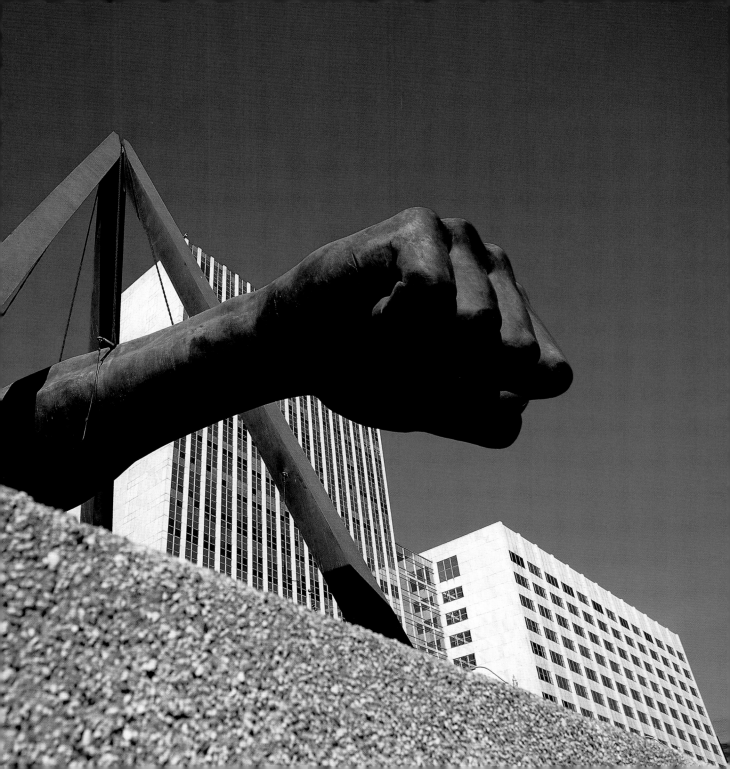

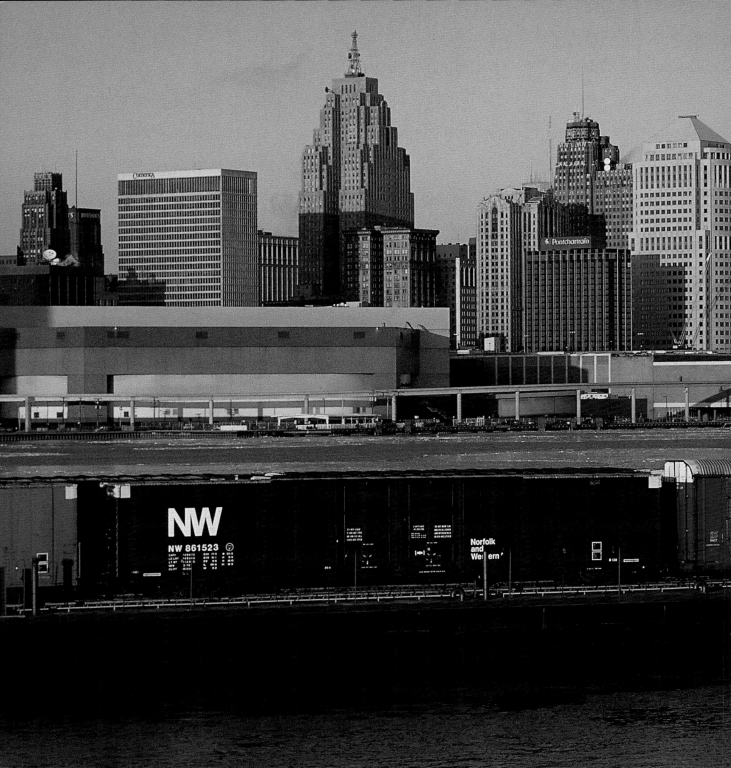

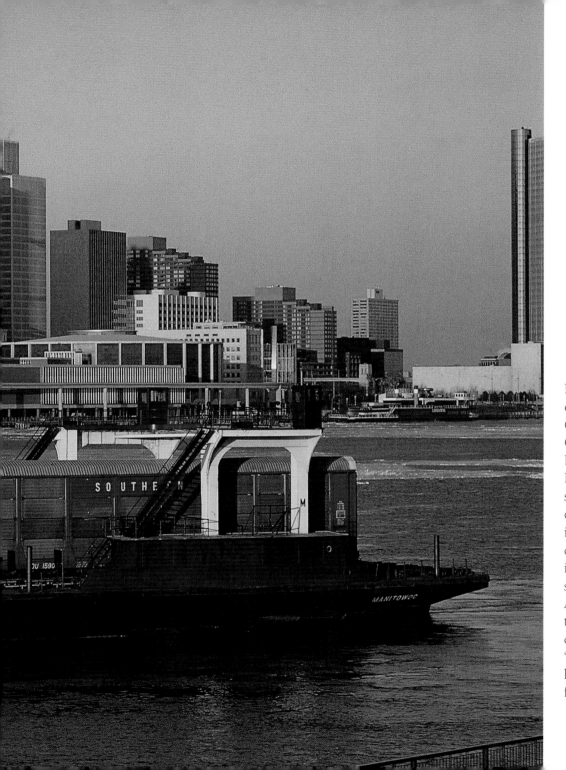

Detroit's port is one of the largest of the 65 ports that dot the Great Lakes Saint Lawrence Seaway. Because the lakes' shipping community developed largely independently of its ocean counterparts, it cultivated its own shipping terminology. A "laker" is a ship that primarily trades on the lakes, while a "salty" is a boat that has traveled inland from the ocean.

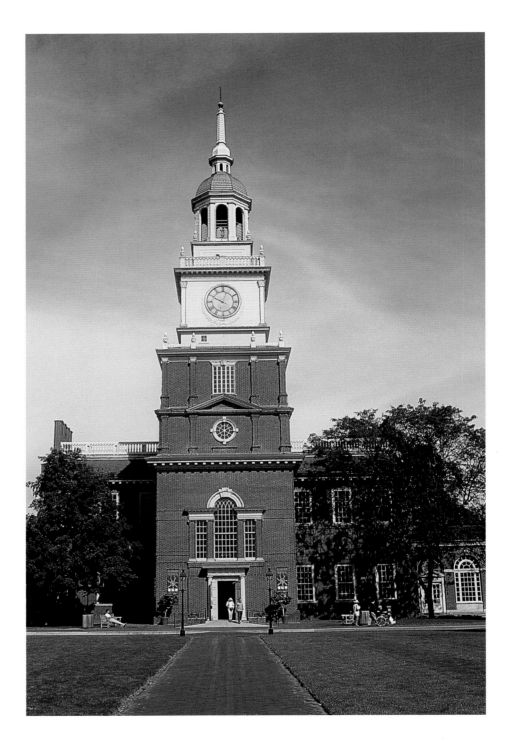

With nine acres of exhibits, the Henry Ford Museum is the largest in the nation. From classic automobiles and the first successful helicopter to sewing machines and dishwashers, exhibits and artifacts trace the evolution of American culture.

16

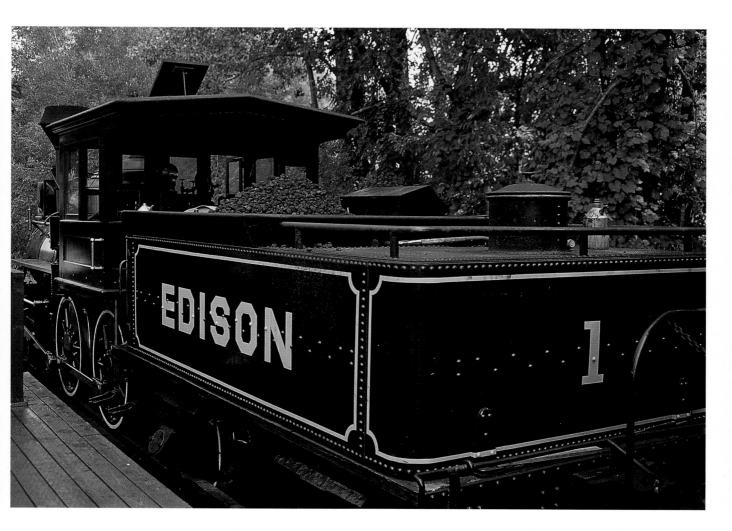

Picturesque steam engines, passenger trains, and huge mining locomotives are all included in the Henry Ford Museum's trains collection. Throughout the summer, visitors can hop a train pulled by an original steam locomotive for a whirlwind tour of Greenfield Village.

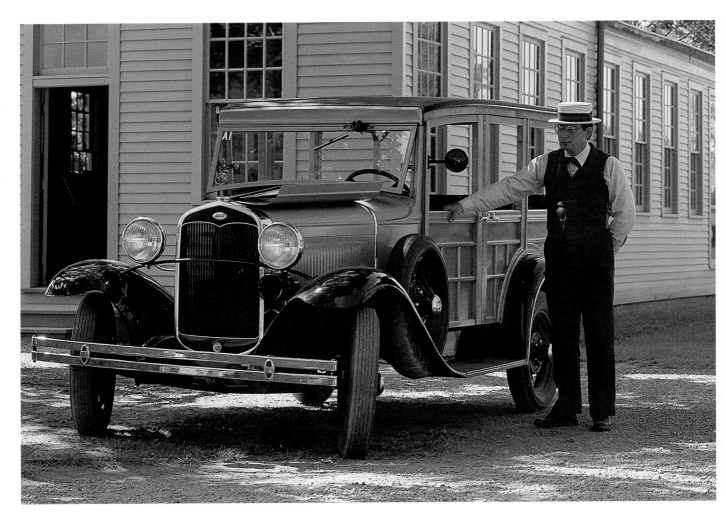

Costumed staff in Greenfield Village bring history to life. Along with this 1931 Model A Ford, visitors to the museum and village can see hands-on examples of Henry Ford's first models, a Model T Ford, and hundreds of other examples of transportation innovation.

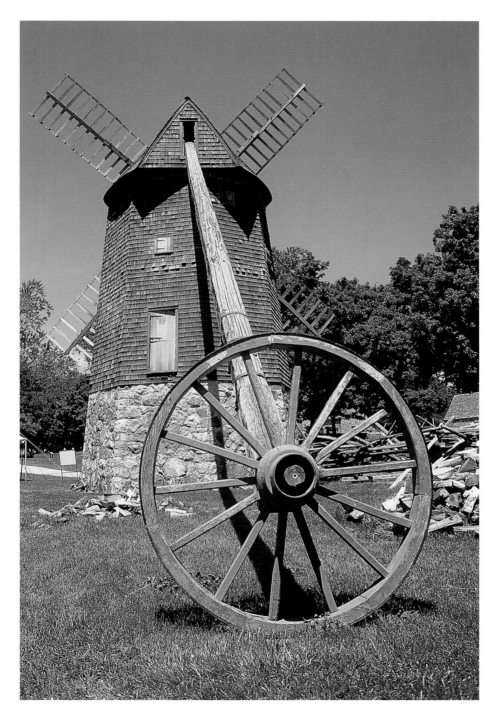

This tower windmill in Greenfield Village is a transplant from Cape Cod, where it was built in the 1600s to capture the energy of strong ocean winds. This is one of several examples of early industry and invention within the village, including a silk mill, a carding mill, and a forge.

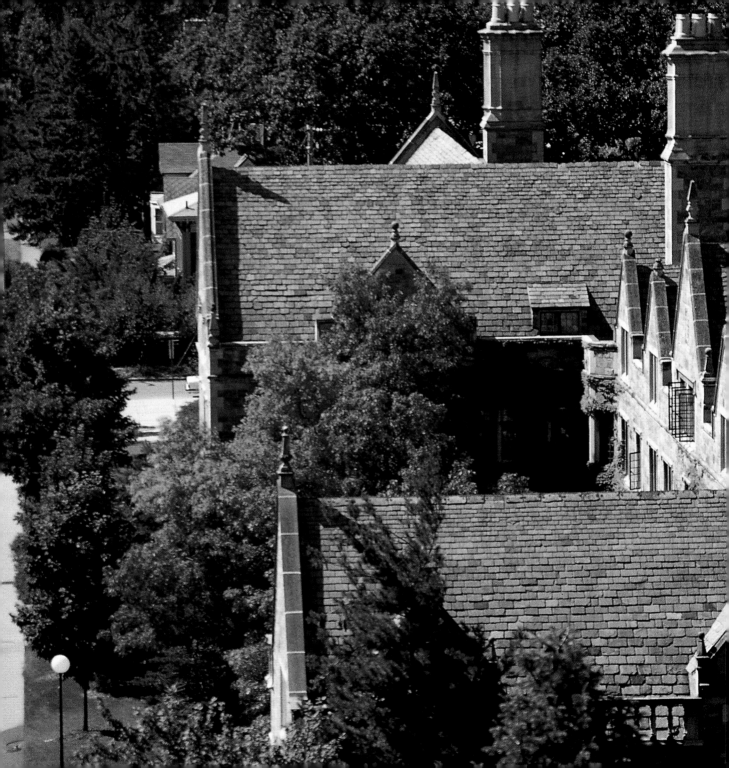

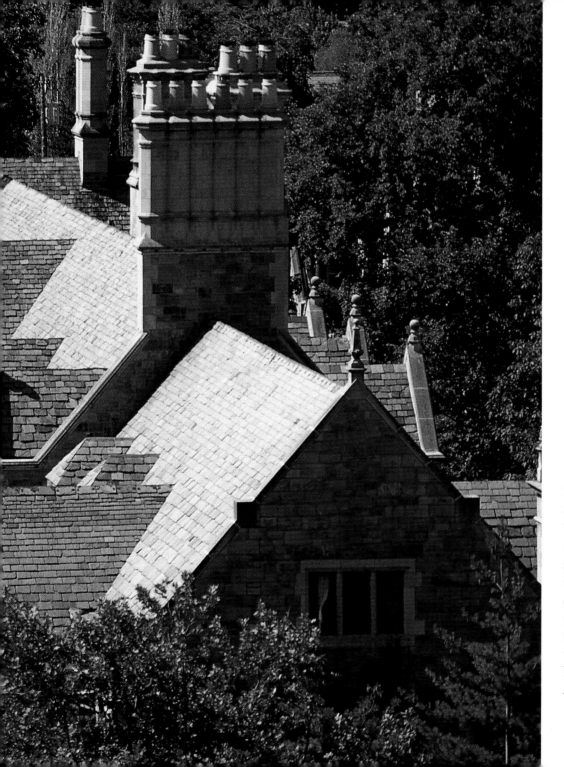

Founded almost two
centuries ago, the
University of Michigan
offers programs from
architecture and law
to music and medi-
cine. Graduates of
the school help make
the city of Ann Arbor
the fastest-growing
high-tech center in
America.

21

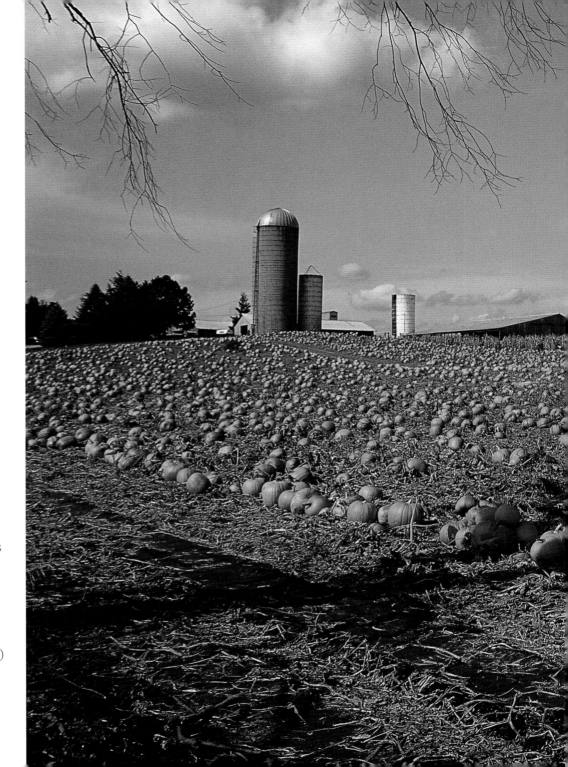

Crops ready for harvest are signs of state fair season in Michigan. Numerous county fairs, the Upper Peninsula State Fair, and the Michigan State Fair (an annual event for more than 150 years) celebrate summer's bounty.

22

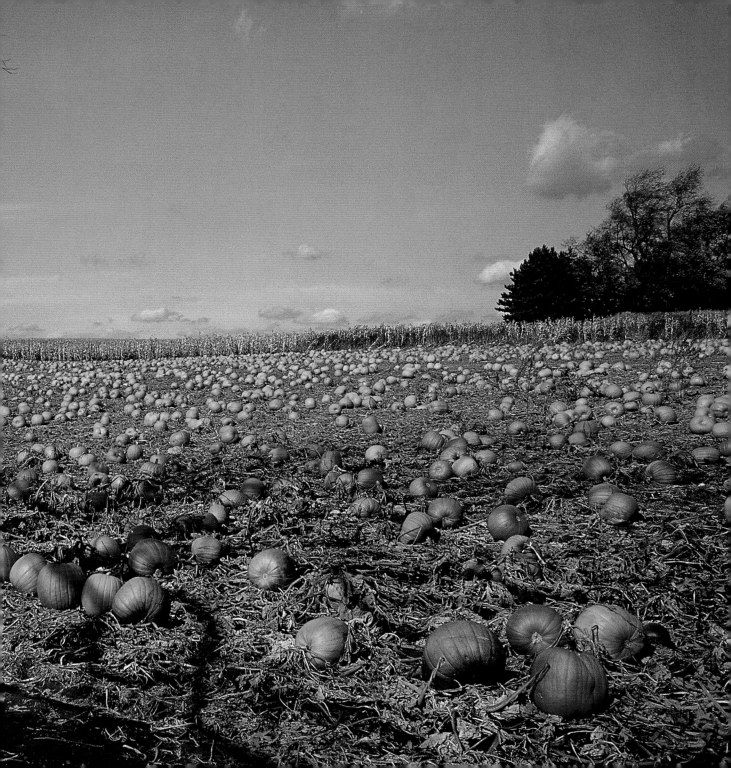

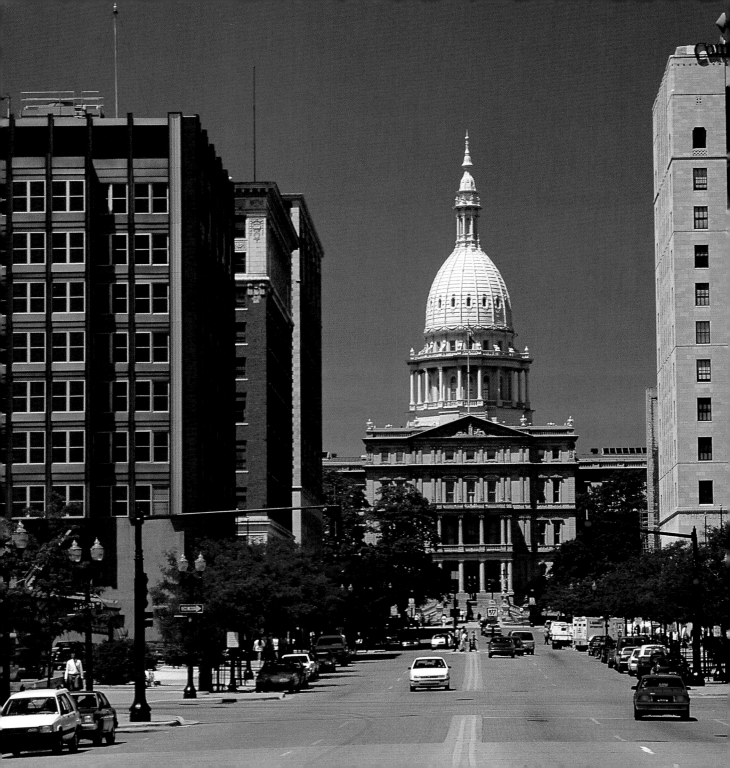

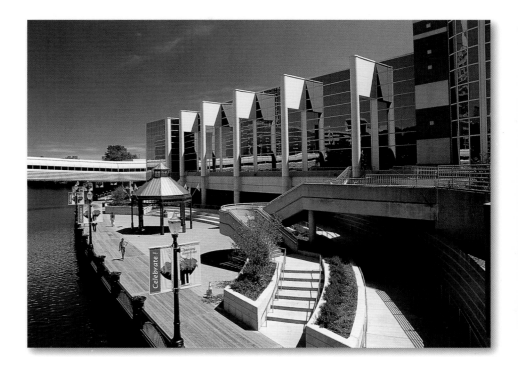

With a riverfront walking trail, local golf courses, microbreweries, and baseball games, Lansing—Michigan's capital—offers enough activities to keep sightseers entertained year round.

Built in 1879 and restored in 1992, the State Capitol features a striking exterior based on the design of the U.S. Capitol. The building's interior, a well-preserved example of Victorian decorative art, has earned it the designation of National Historic Landmark.

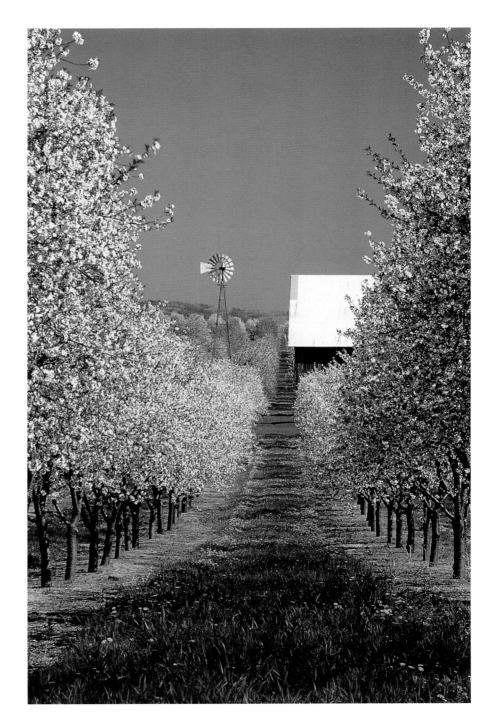

Michigan is America's top producer of tart cherries and blueberries. Apples, plums, asparagus, grapes, strawberries, cucumbers, and peaches also find their way from the state's fertile fields into produce stores across the country.

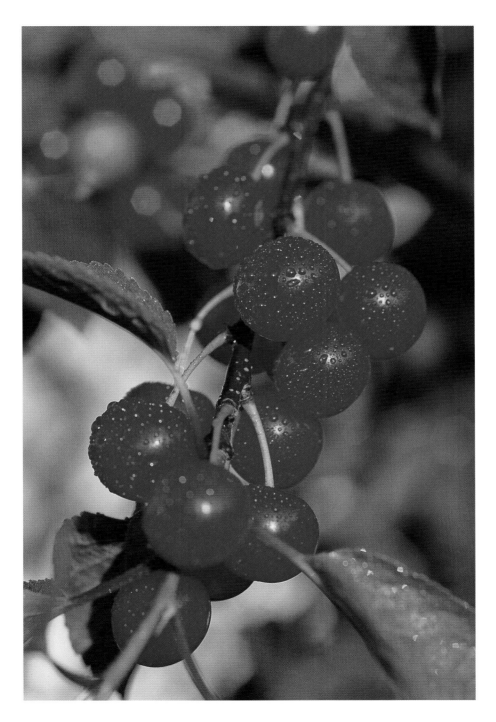

Cherries ripen in an Owosso orchard, one of 2,000 farms in Shiawassee County. The community of Owosso was named for Chief Wasso of the Shiawassee native people, who lived here until they were moved to a nearby reserve in the early 1800s.

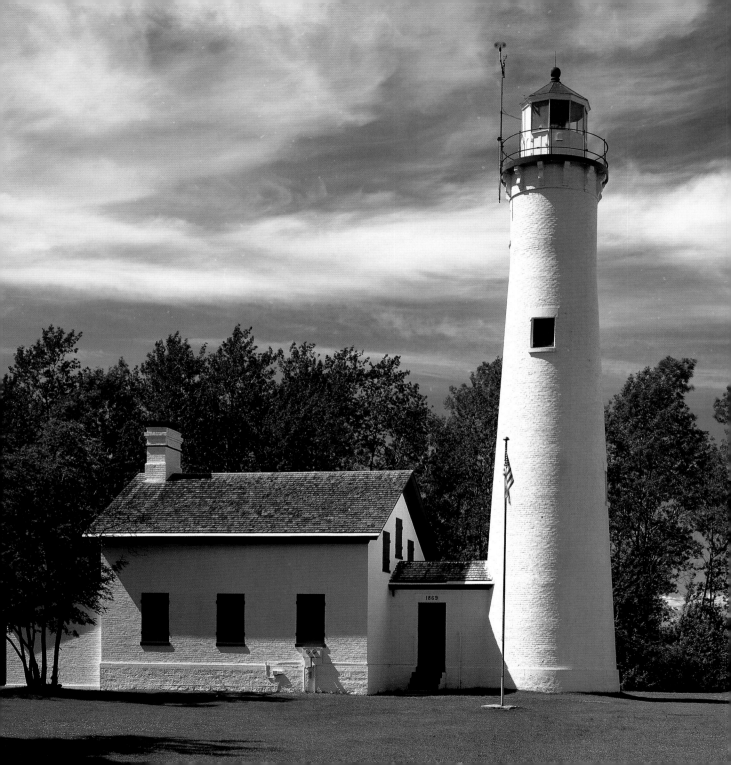

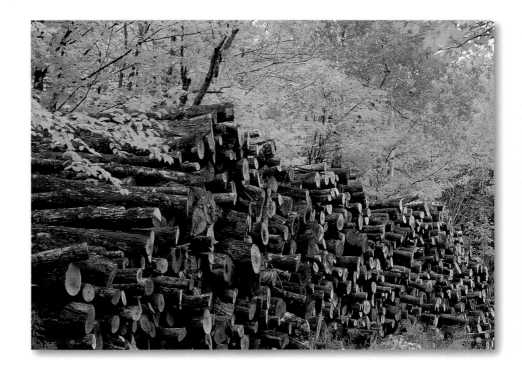

In the late 1800s, Michigan led the nation in sawed wood production. Shanty camps housed thousands of lumberjacks, hewing "green gold" from the wilderness. In 1869, the Saginaw Valley produced $7 million worth of timber.

Sturgeon Point Light in Alcona County is both a museum and an operating beacon. The lighthouse warns mariners of the rocky shoreline and of a hidden gravel bar extending into the Lake Huron waters.

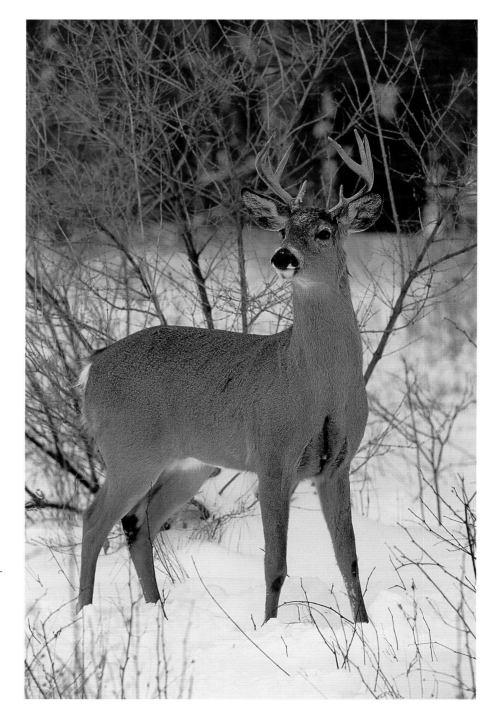

A white-tailed buck picks its way through the trees of Au Sable State Forest. While thick woods protect these deer from predators—including hunters—they're not above wandering into agricultural areas for easy meals in corn and alfalfa fields.

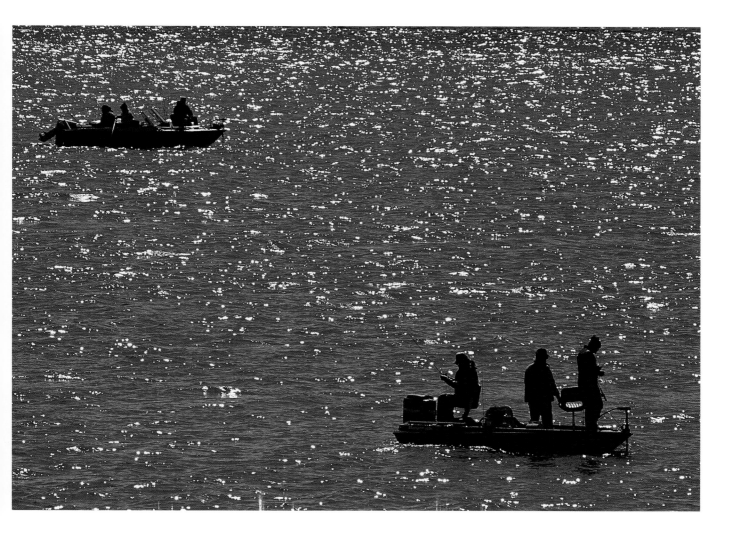

Fishing enthusiasts are busy year round on the state's innumerable inland lakes and rivers. Walleye, steelhead, perch, trout, and bass attract boaters in summer and ice fishers in winter, while the adventurous try downrigging for salmon on the waters of the Great Lakes.

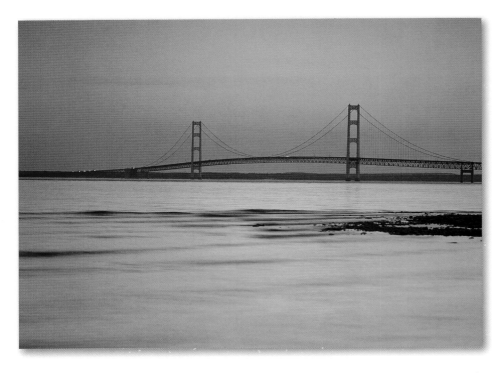

Five miles long, the Mackinac Bridge spans the Straits of Mackinac in north-west Michigan. About 350 engineers helped plan the structure, and 3,500 workers were involved in the construction. The bridge opened in 1957.

Though built in 1871, the 113-foot beacon at the northern tip of the Presque Isle Peninsula is known as the New Presque Isle Light. Its predecessor, a short distance away, is said to be haunted by the ghost of a lightkeeper's wife, driven mad by loneliness.

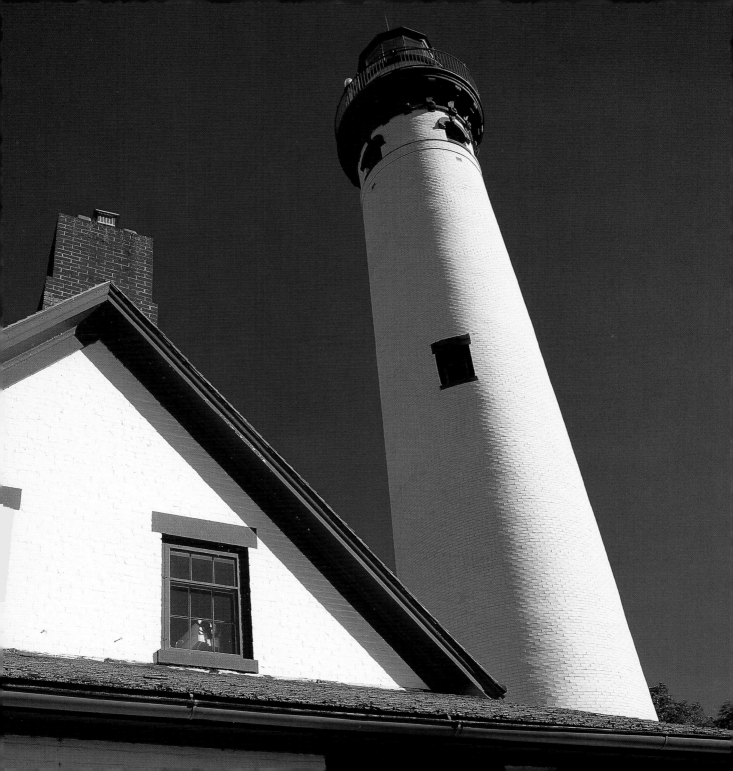

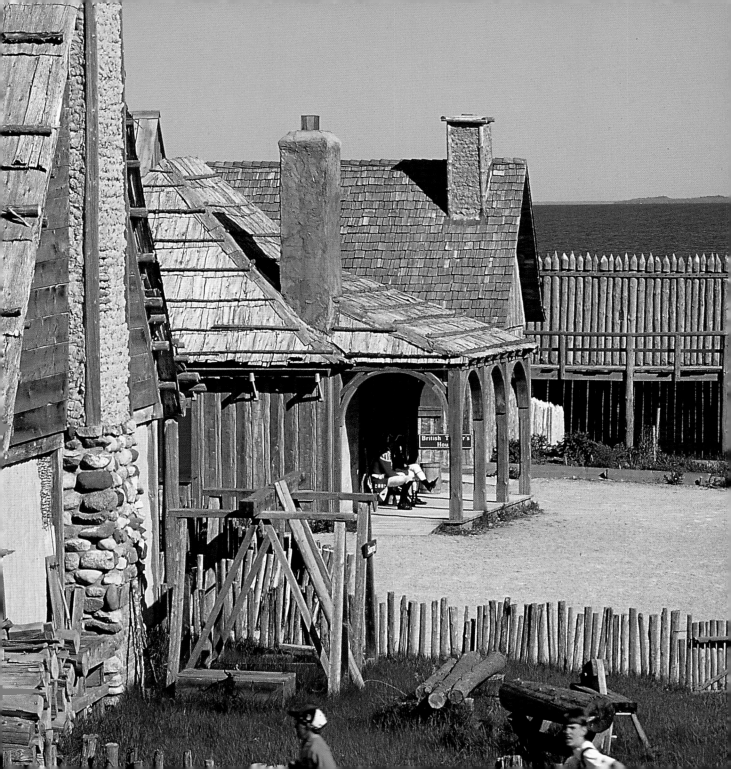

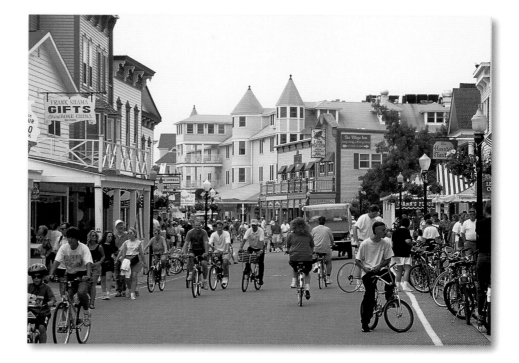

Once home to native burial sites and fur-trading outposts, Mackinac Island became a popular summer retreat as early as the 19th century. Automobiles aren't allowed, so visitors sightsee on foot, by bicycle, or by horse-drawn carriage.

Visitors sample pastries in the tea room, children learn about the history of the outpost, and costumed staff host rifle and cannon demonstrations. Fort Mackinac includes 14 original historic structures, including the oldest building in the state.

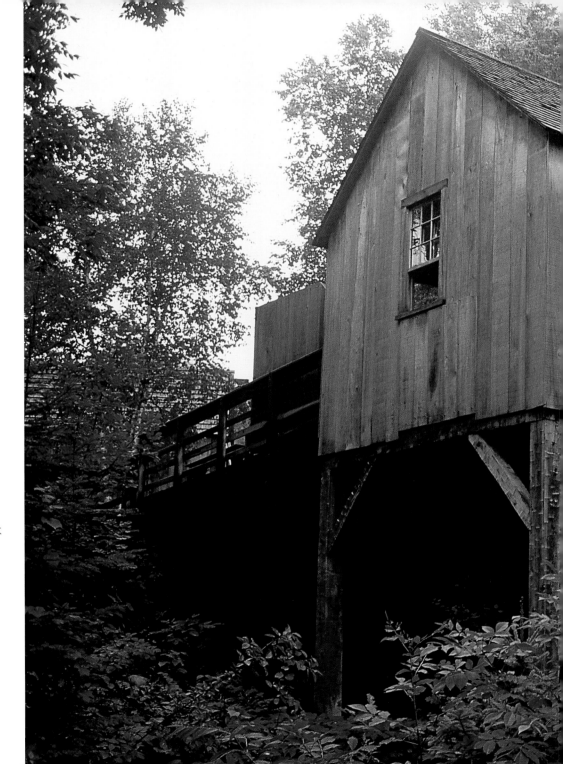

Mill Creek State Park features 625 acres of walking trails and wildlife habitat, and preserves one of the oldest sawmill sites on the Great Lakes. The water-powered machines are still operational.

36

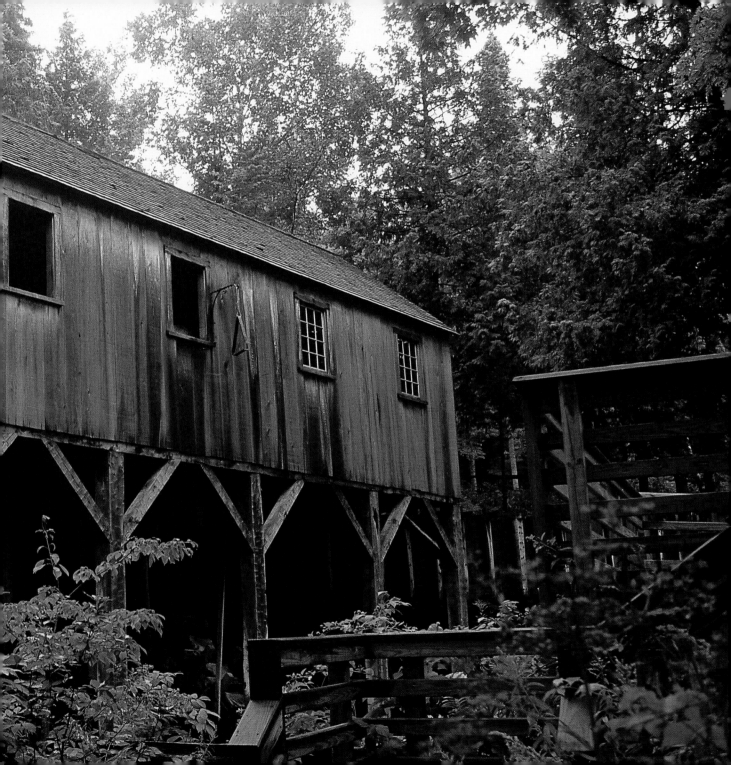

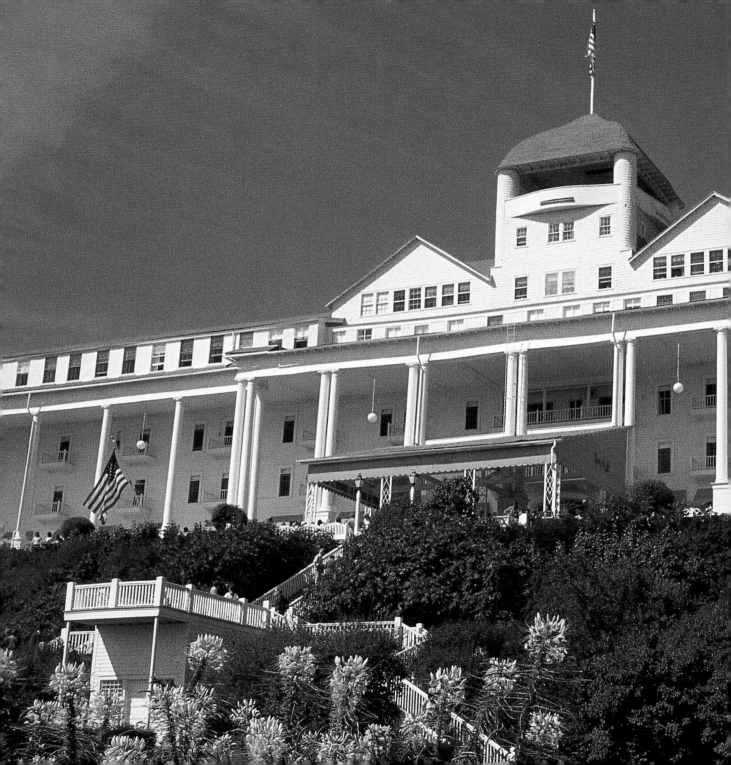

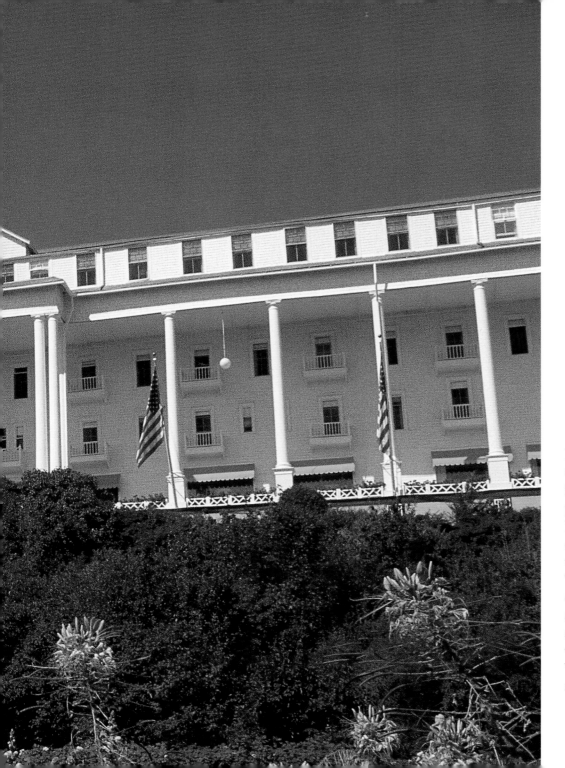

Mackinac Island's Grand Hotel was built in 1887 by entrepreneur John Oliver Plank, who hoped to cater to the island's upper-crust visitors. Today's guests can enjoy the luxurious accommodations and stroll the 660-foot verandah just as the Victorian gentry did a century ago.

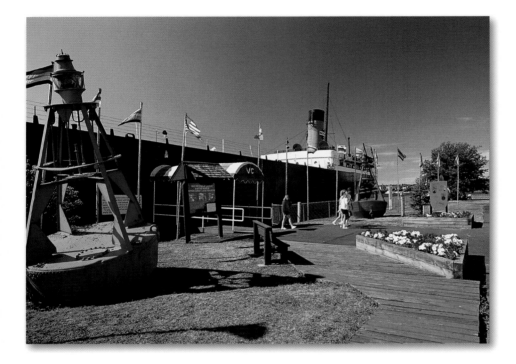

A fishing place for native people for over 2,000 years, Sault Ste. Marie was settled by fur traders in 1668, making it the third-oldest continuous settlement in America. It was named by Jesuit missionaries in honor of the Virgin Mary.

The Sault Locks transport ships up and down the 21-foot drop of the St. Mary's Rapids, along the waterway between lakes Huron and Superior. The first US lock was built here in 1855. Previous locks on the Canadian side were destroyed during the War of 1812.

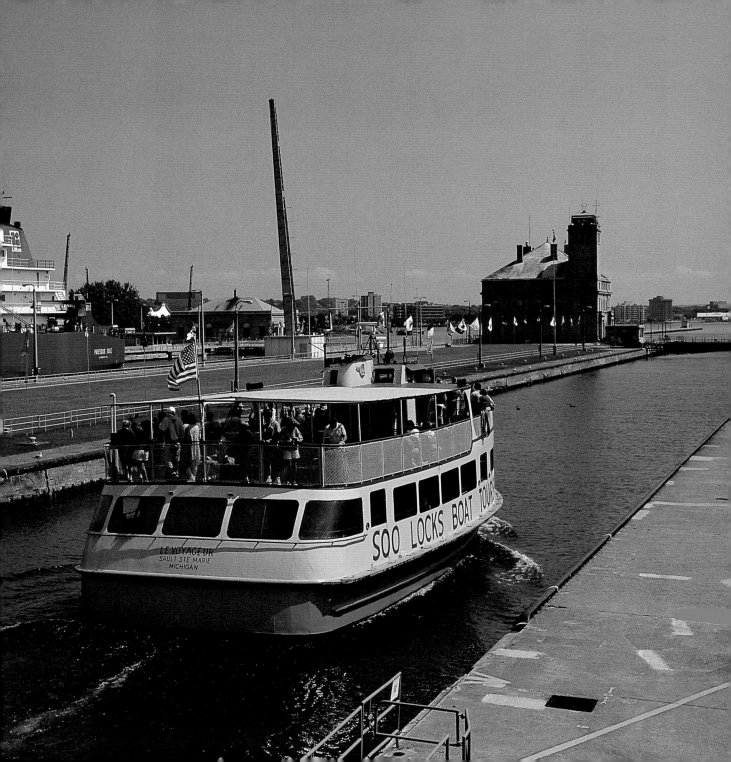

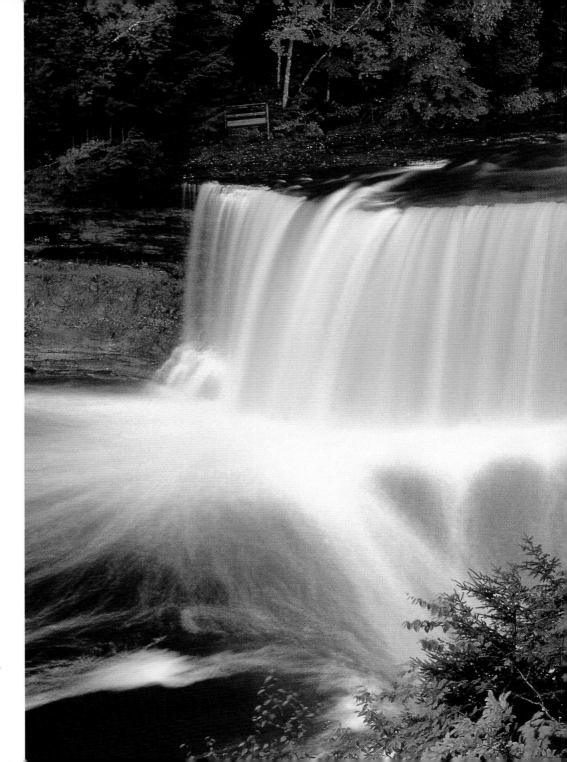

The Tahquamenon River drains 820 square miles and runs for more than 90 miles before reaching Lake Superior. Just before its destination it drops 50 feet— sometimes at a rate of 50,000 gallons per second—over the spectacular Tahquamenon Falls, then through a series of smaller falls.

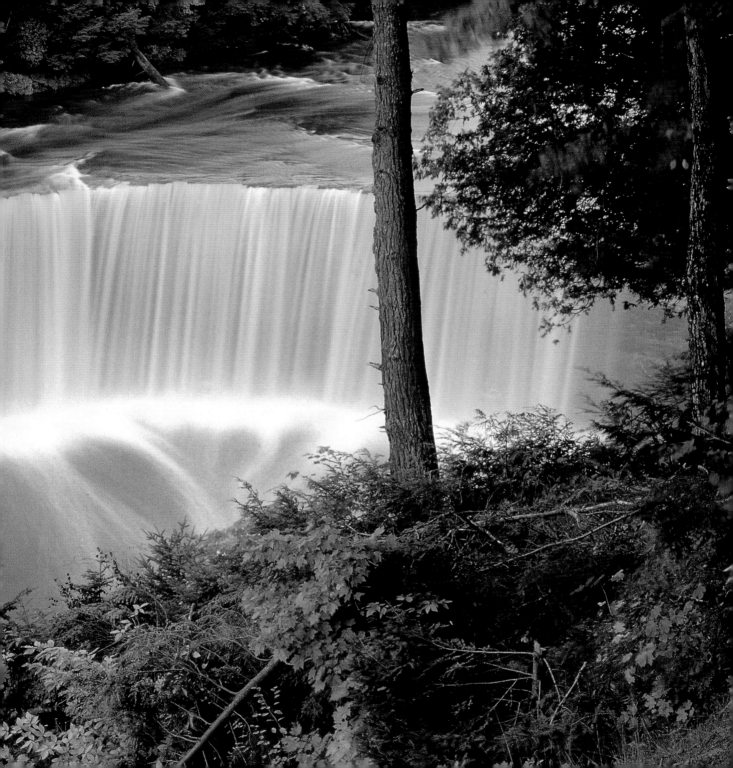

Connecting the rugged shores of lakes Huron, Superior, and Michigan, Hiawatha National Forest covers a vast 880,000 acres. From picnic sites in old-growth groves to challenging hiking trails and serene fishing spots, the forest holds unlimited recreational opportunities.

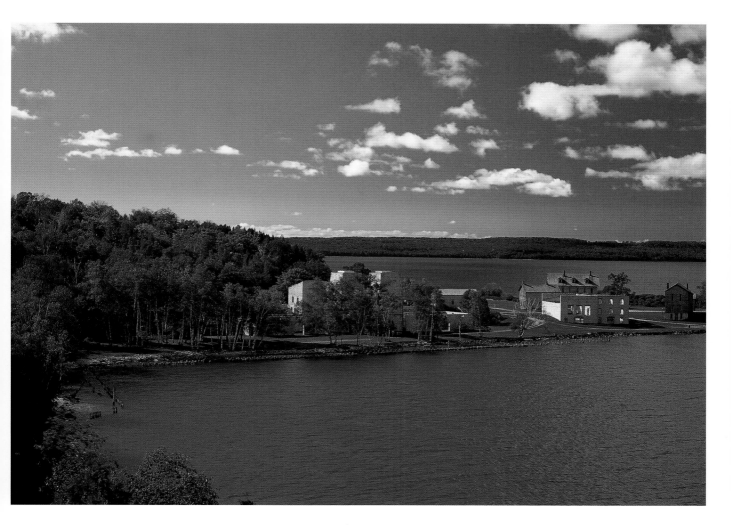

Jackson Iron Company agent Fayette Brown chose the site for one of Michigan's largest iron-smelting plants in 1867. The plant produced 229, 288 tons of iron over two decades of operation. It is now preserved as a state historic park.

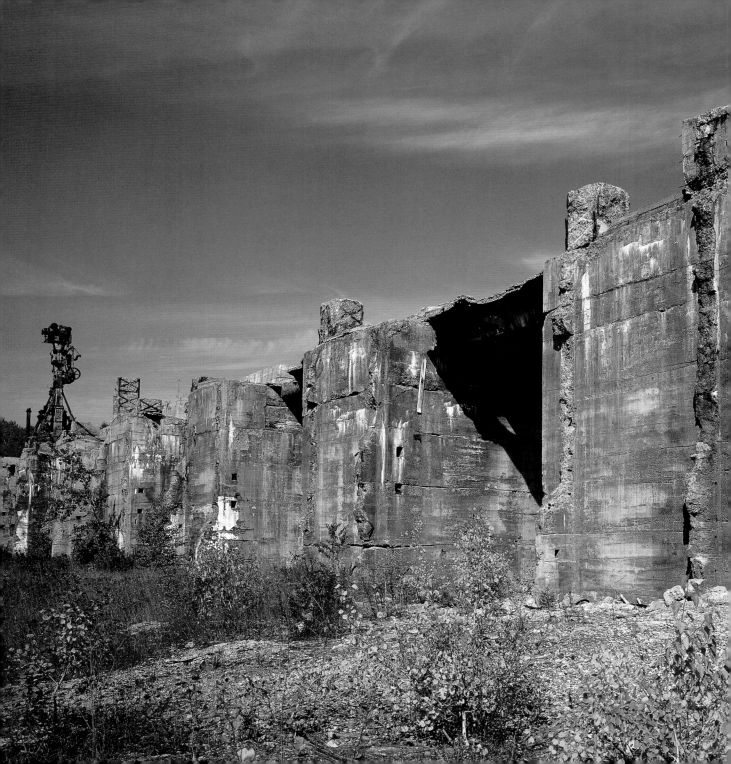

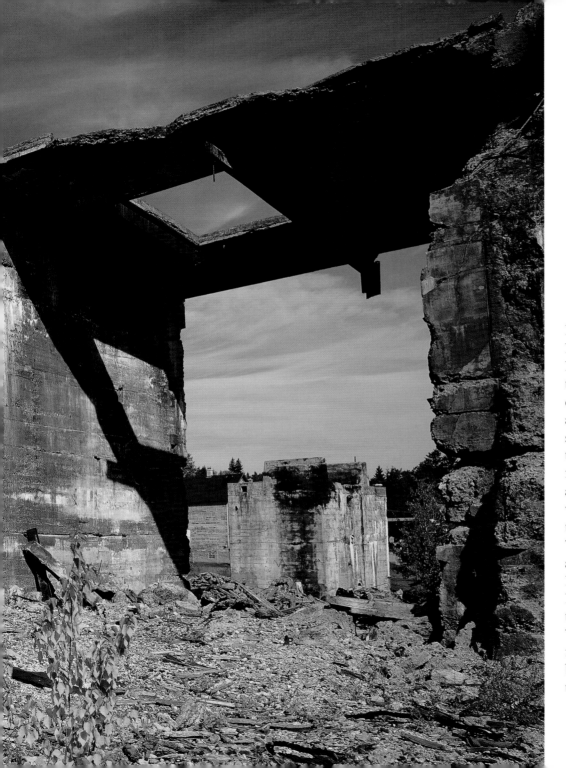

In the late 1800s, Michigan's Upper Peninsula was home to many iron and copper mines, as well as the towns that sprang up around them. When the market for these metals declined, mines were closed and towns abandoned. Today, their ruins are a common sight in Michigan's parks. In Fayette State Park, the Fayette Historic Townsite has been restored and its buildings opened to the public.

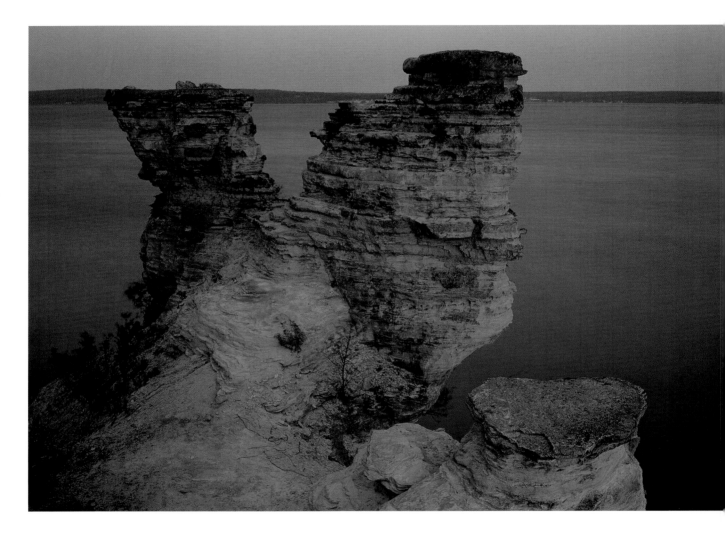

Pictured Rocks National Lakeshore, where the endless waves of Lake Superior have exposed layered cliffs of multicolored stone, became the nation's first designated national lakeshore site in 1966. The oldest exposed rock here is more than 400 million years old—a red sandstone newly exposed by erosion.

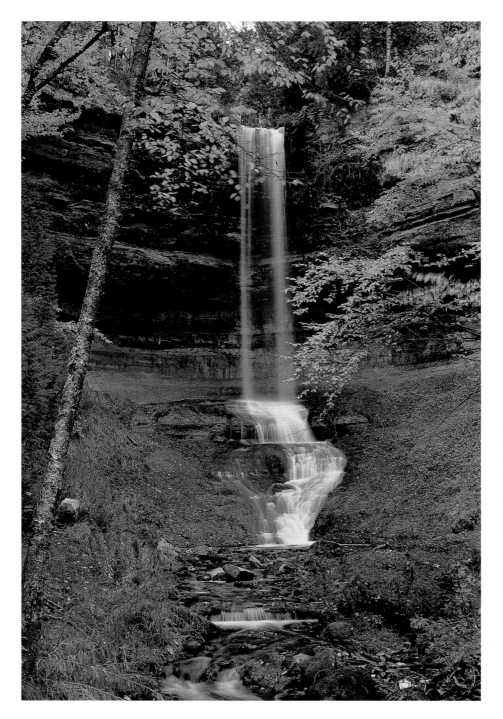

October is a favorite time to visit Pictured Rocks National Lakeshore. The maples are the first to change color, followed by the aspen and birch. Finally, the tamaracks blaze brilliant yellow late in the month. By Halloween, the first snow has usually dusted the woods.

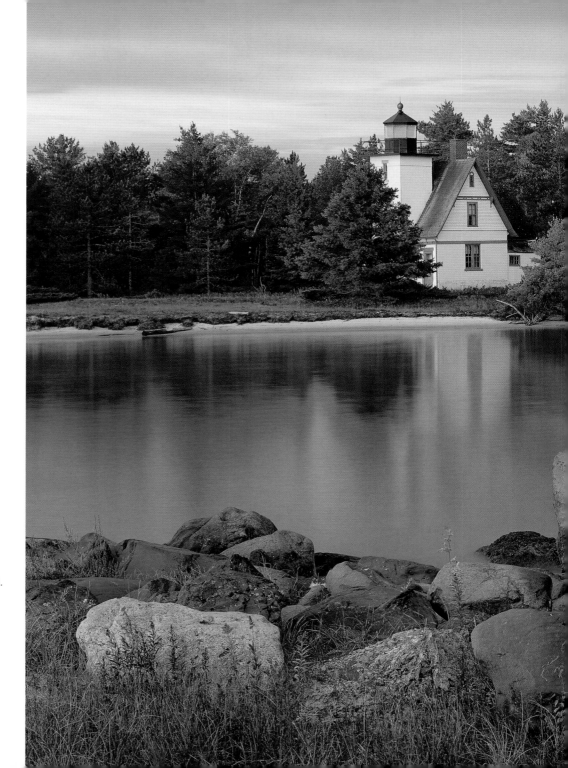

Bete Grise is a tiny cluster of buildings around an 1895 lighthouse, built along the Mendota Ship Canal between Lac La Belle and Lake Superior. The *Langham*, a 280-foot wooden steamer, burned here in 1910. It is now one of 32 vessels protected for researchers and divers as part of the Keweenaw Underwater Preserve.

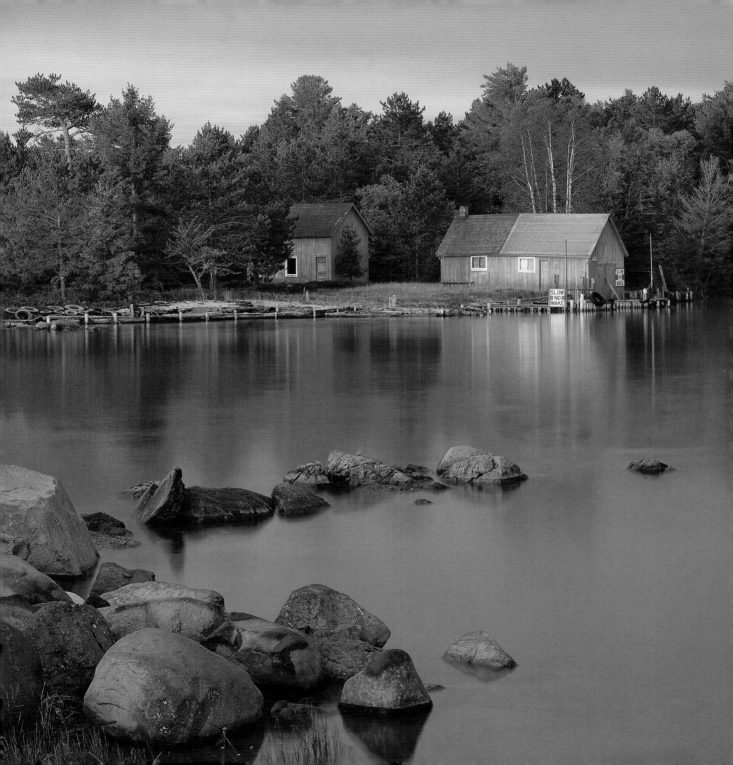

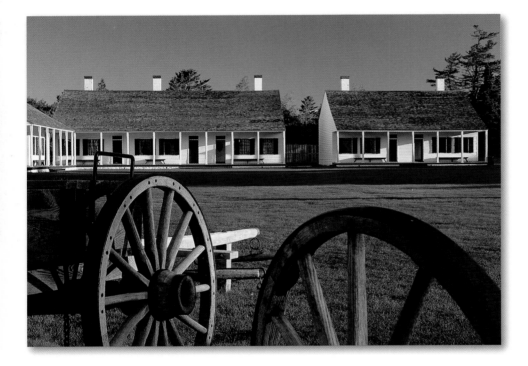

Fort Wilkins had a short life as a US Army outpost. It was used from 1844 to 1846 and in the 1860s. Today, costumed staff and restored buildings allow visitors to experience 19th-century life.

There are no cars in Isle Royale National Park—the sanctuary is accessible only by boat or floatplane. Once there, hardy backpackers can follow 166 miles of hiking trails along rugged coastlines, past solitary lighthouse beacons, and through glacier-carved forest basins.

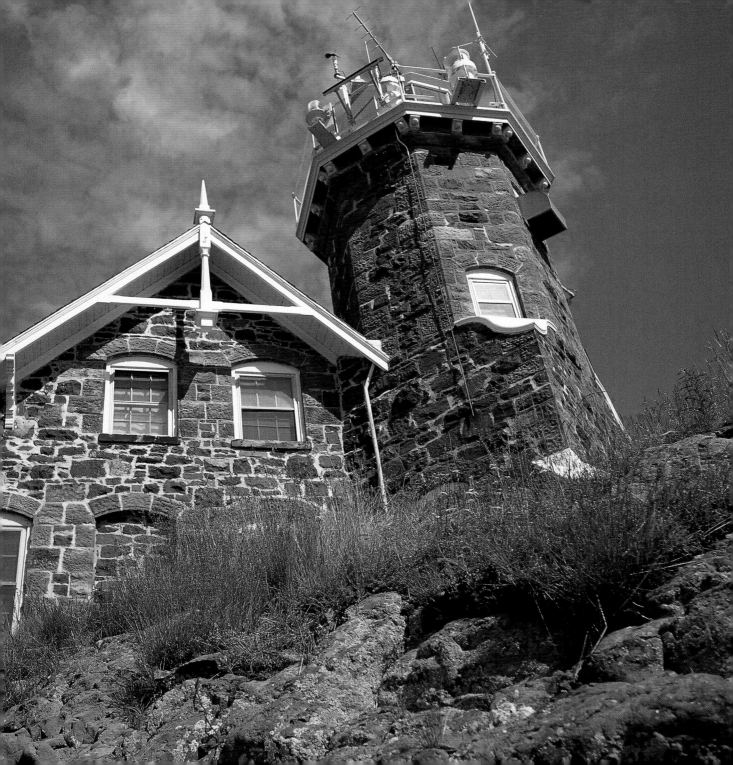

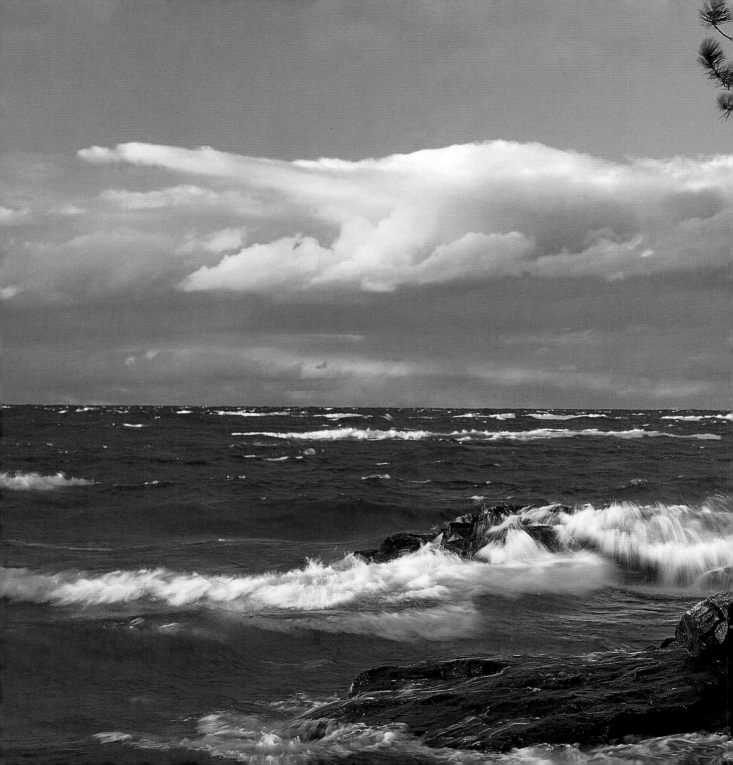

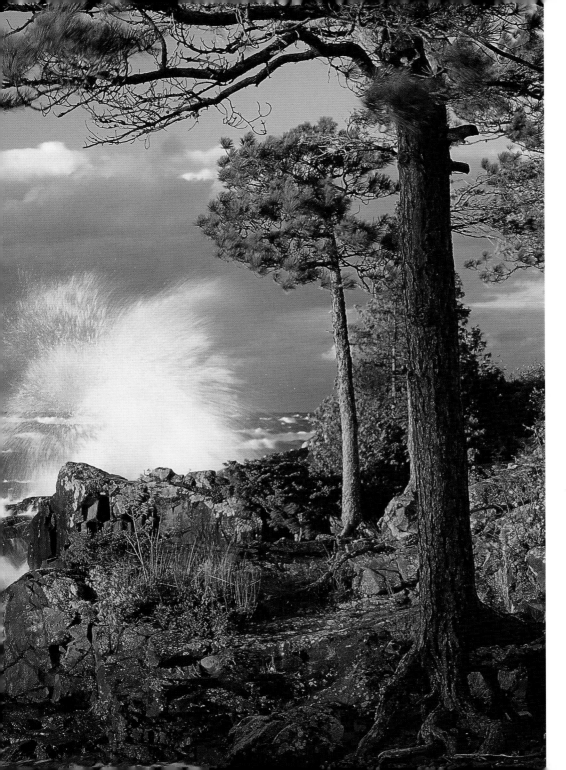

The northernmost village in Michigan, Copper Harbor was a primary shipping point for the copper discovered on the Upper Peninsula in the mid-1800s. Today, the boats that ply these waters are ferrying passengers to the shores of Isle Royale National Park.

The largest island in Lake Superior, Isle Royale is 45 miles long and 9 miles wide. The wilderness habitat supports rare orchids, small animals, and thriving moose and wolf populations, prompting the United Nations to name it an International Biosphere Reserve.

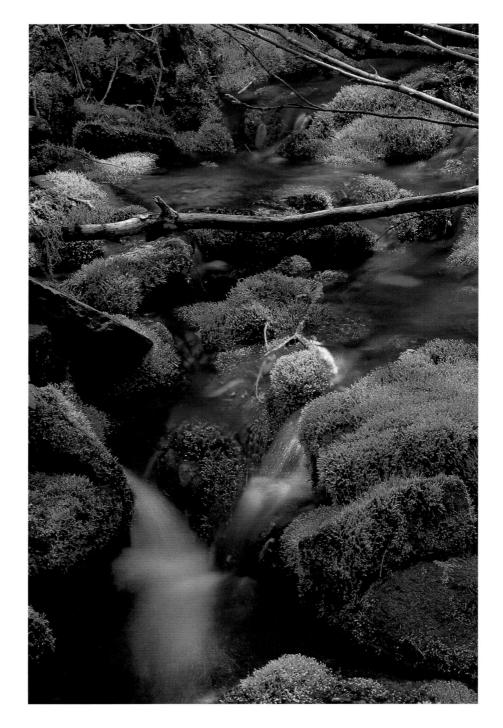

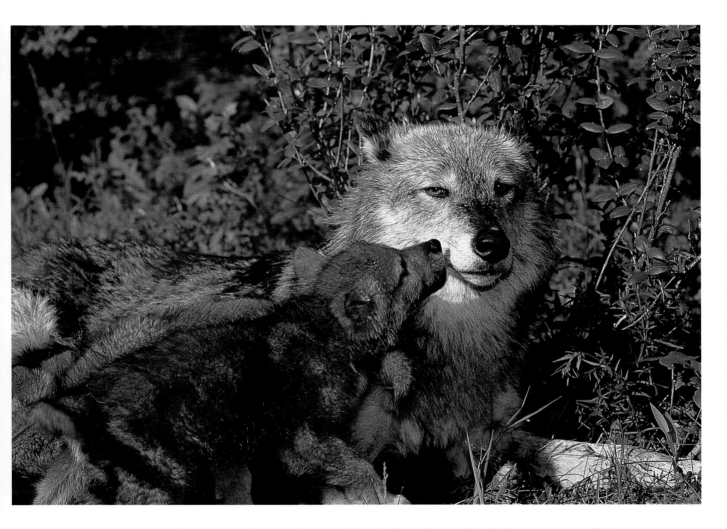

About 30 wolves in three packs inhabit Isle Royale, helping to control the moose population of 700 to 900 animals. The wolves have been on the island since the 1940s, having crossed the winter pack ice from either Minnesota or Ontario. Environmentalists track them carefully, ensuring the once-endangered population remains strong.

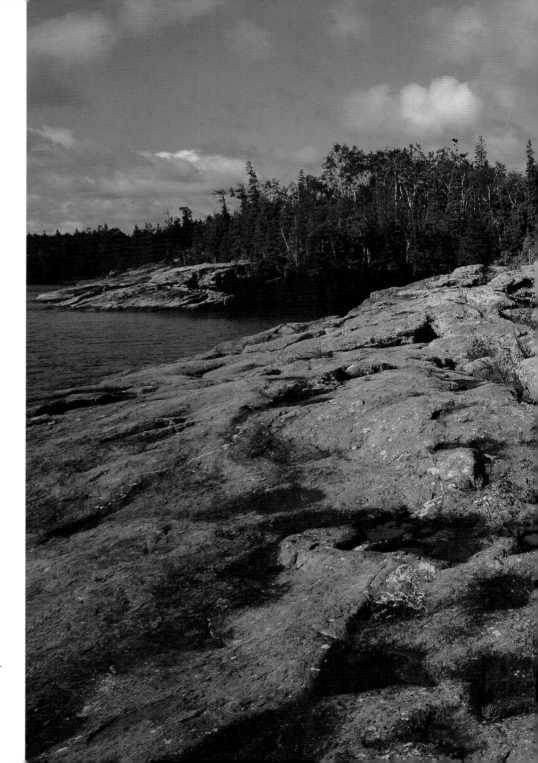

Lake Superior, more than a thousand feet deep and hundreds of miles long, surrounds Isle Royale National Park. This is the largest of the Great Lakes. In fact, despite the huge volume of water pouring in, it takes about 190 years for the water that's held here to be completely replaced.

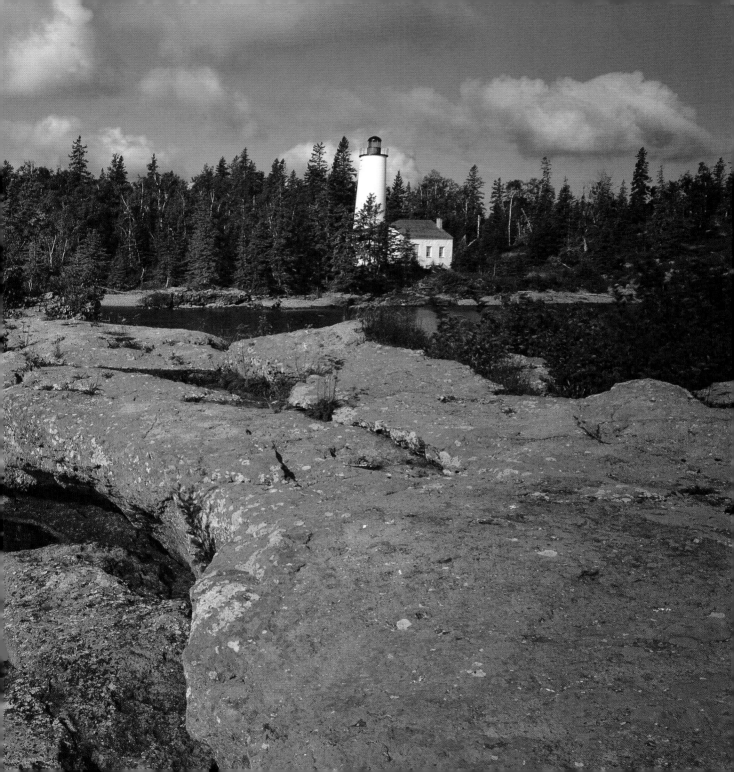

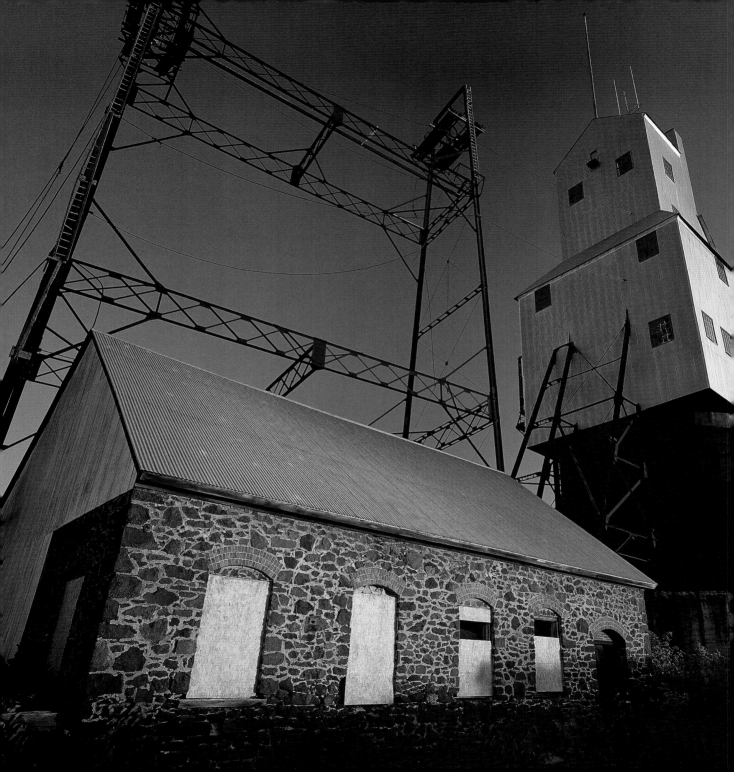

A harbor town with a rich mining past, Ontonagon is the gateway to the Porcupine Mountains, offering hiking and paddling in the summer and some of the state's best skiing in the winter.

The Keweenaw Peninsula, with its rich copper deposits, was home to the first mineral rush in the country. Between 1890 and 1910, more than 60,000 people lived in the area, supported by the booming industry. But strikes and drops in demand led to massive mine closures. The last mine closed in 1968.

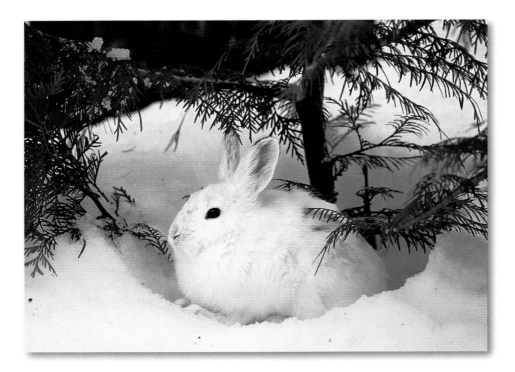

This snowshoe hare is hard to spot in summer, but its tracks in the winter snow have led the photographer to where the animal lies camouflaged. When it runs, it spreads its toes on its huge hind feet, creating natural "snowshoes."

Porcupine Mountains Wilderness State Park is the largest state park in Michigan, encompassing 60,000 acres. The park—named for the mountains affectionately known as the Porkies—was established in 1945 to protect the largest old-growth hardwood-hemlock forest in the Midwest.

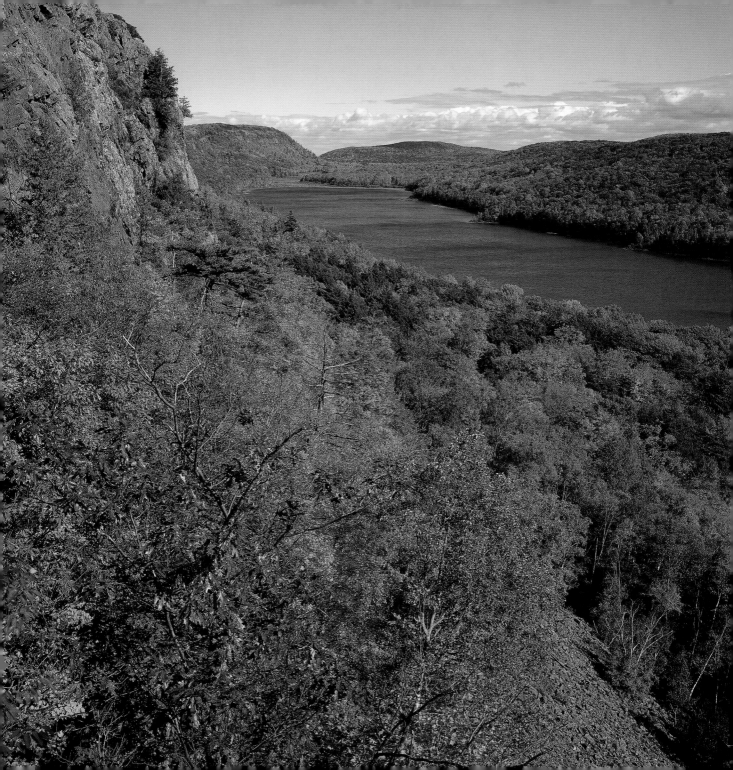

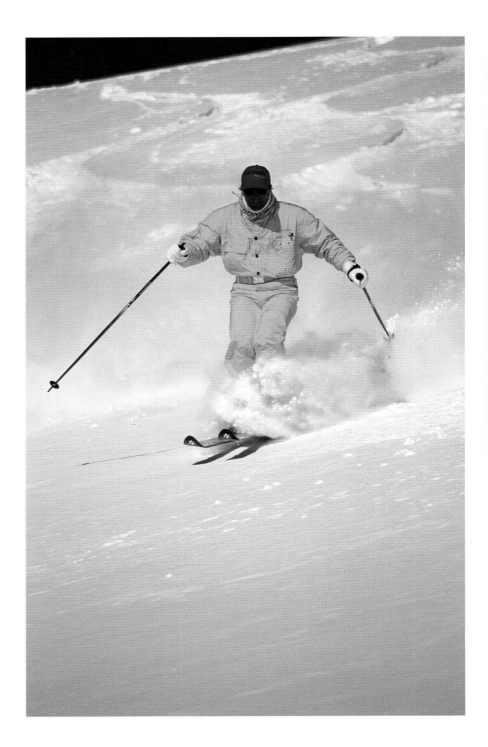

Each winter, warmer air picks up moisture above Lake Michigan before moving on toward the Upper Peninsula, where that moisture drops as 20 feet of snow. For skiers in the Porcupine Mountains, the fresh powder and sparsely populated runs are all the encouragement needed to hit the slopes.

Boaters, anglers, and campers flock to Gogebic State Park in summer, but in winter the 360-acre park is transformed into a quiet and remote snowscape.

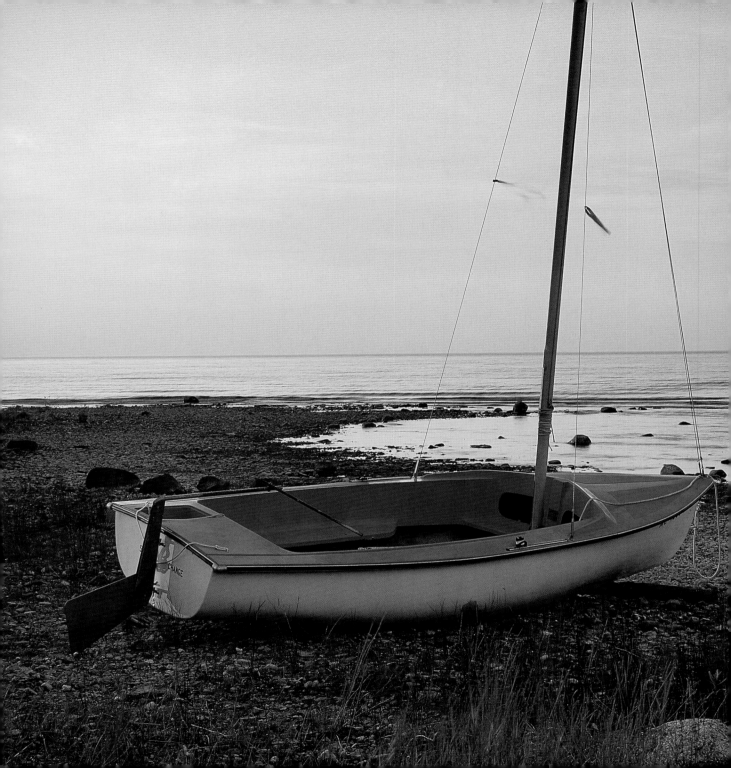

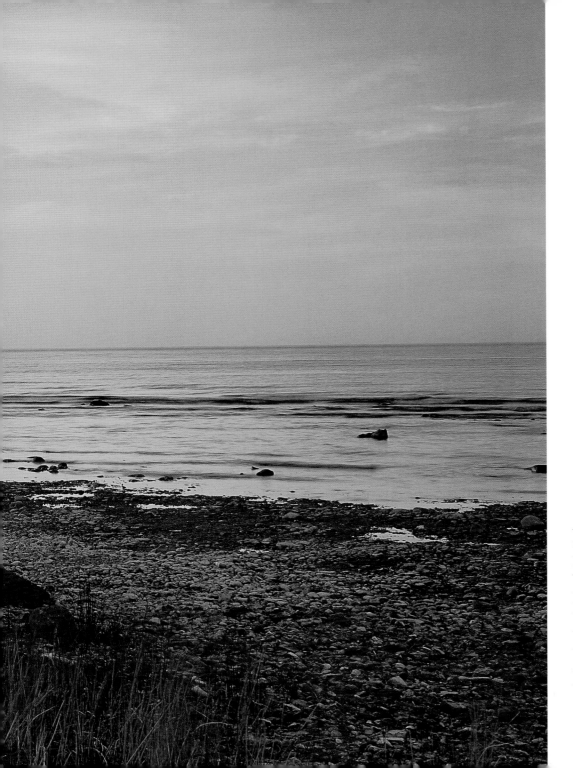

A sailboat rests on the calm shore of Lake Michigan in Wilderness State Park, a tiny preserve that shelters red and white pines, rare wildflowers, and endangered piping plovers.

For more than a century, Harbor Springs has been one of the state's favorite resorts. The beauty and tranquility of the town bring visitors back every summer. Many people who visited as children return with their own children, and even their grandchildren.

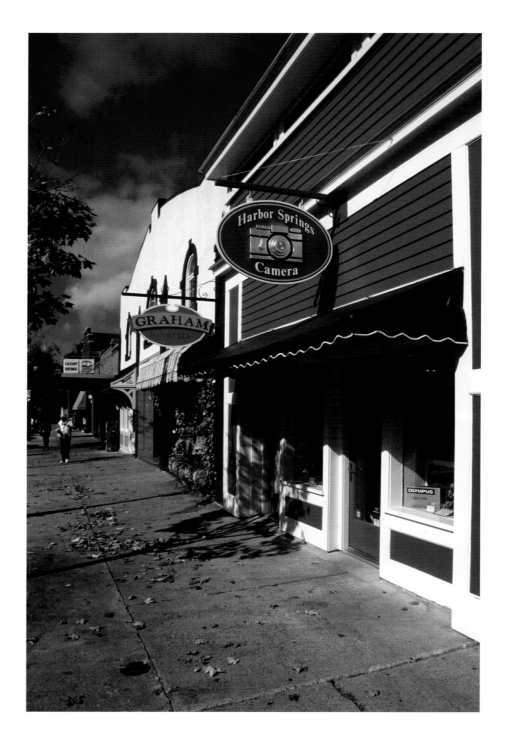

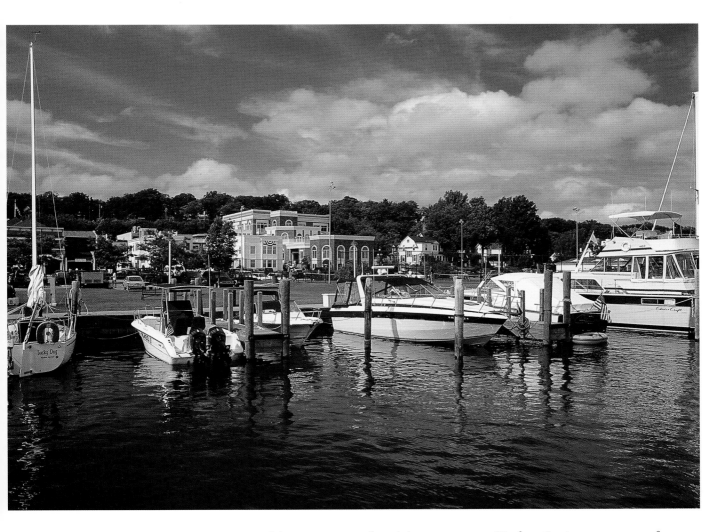

It's easy to see why visitors return to Harbor Springs summer after summer. Sailing, golf, waterskiing, sailboarding, cycling, boating, fishing, and tennis are all just moments away from the downtown shops.

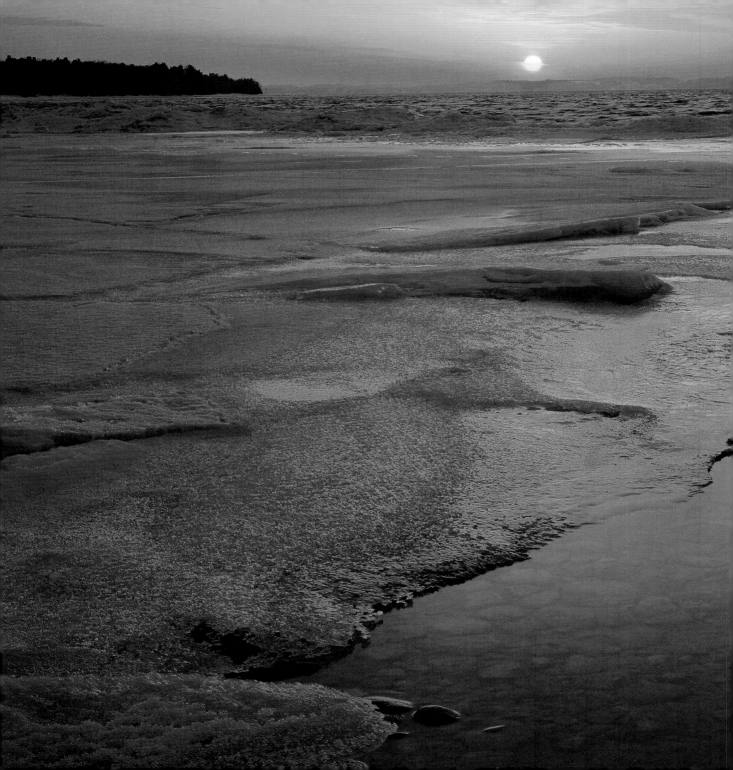

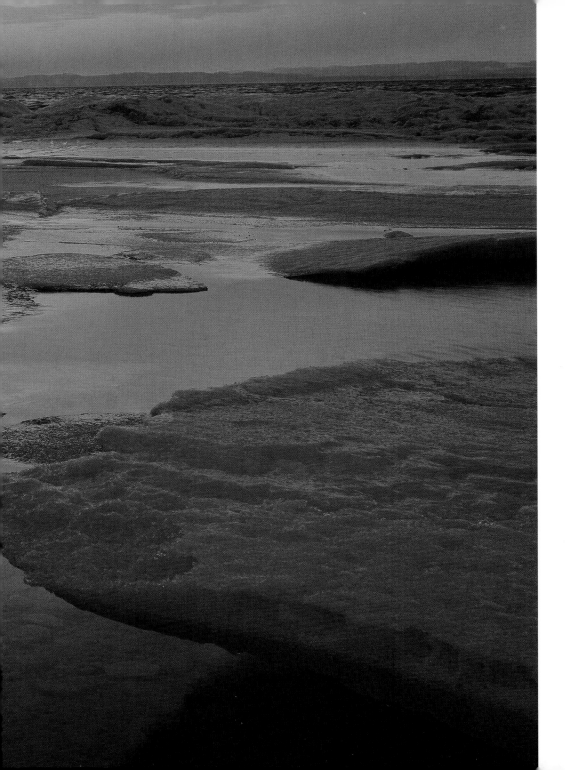

Sunset highlights the ice floes on the west arm of Grand Traverse Bay. Two hundred million years ago, this area was a vast sea. When the waters receded, they left the porous seabed behind, which was later scoured away by ice age glaciers. At its deepest, Grand Traverse Bay reaches 612 feet.

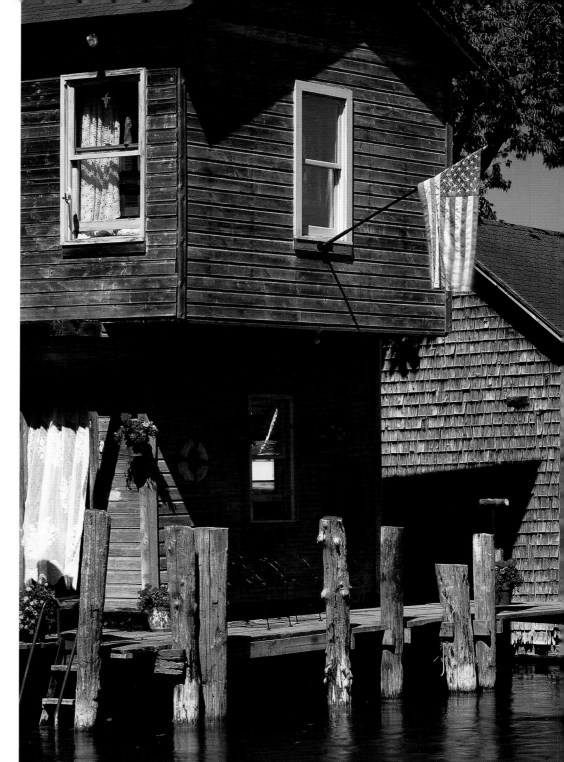

Leland's historic Fishtown District was once home to a fleet of fishing vessels and an ironworks factory. Though no longer the center of city life, the docks here still shelter charter fishing vessels and tour boats.

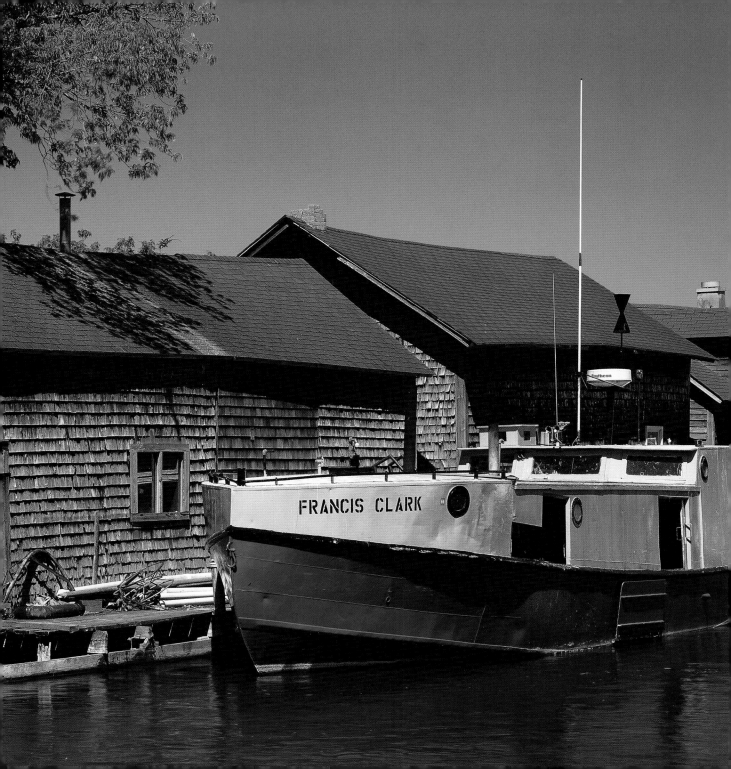

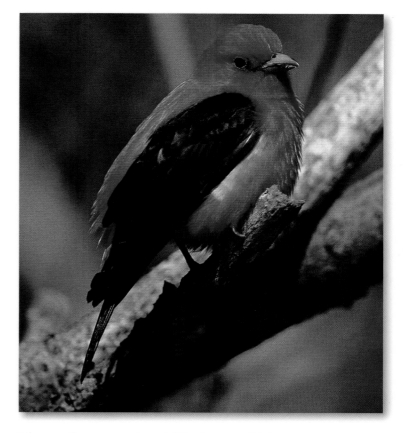

The scarlet tanager's vivid feathers make it easy to spot in Michigan's woodlands. Though most common along the East Coast, the small bird nests throughout the Great Lakes region and as far south as Louisiana.

Leelanau County's first settler, Antoine Manseau, arrived with his family from North Manitou Island in 1853. Steamers along the Great Lakes soon brought more homesteaders, and by 1900 more than 10,500 people lived in the area.

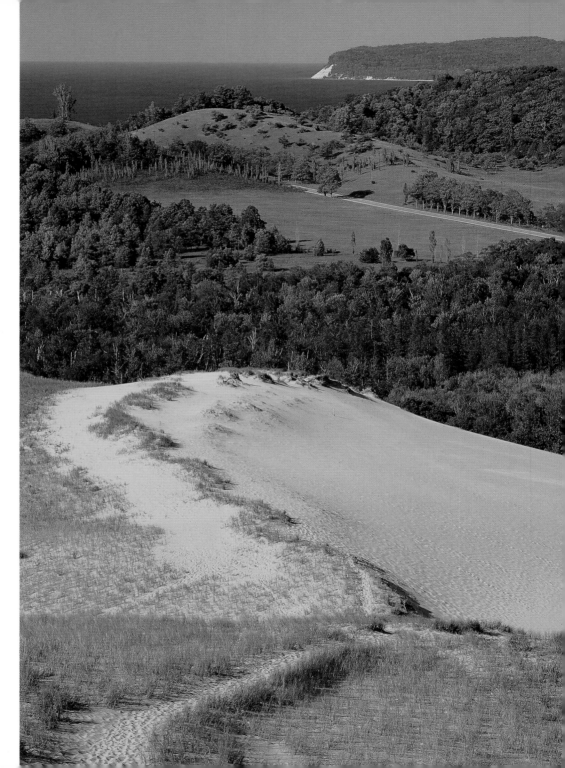

According to native
legend, a forest fire
once drove a bear
and her two cubs
into Lake Michigan.
The mother made it
to safety, but had to
watch from shore as
her cubs drowned in
the icy waters. The
Great Spirit Manitou
marked their pass-
ing with two small
islands, and the
mother's vigil with
a high sand dune in
what is now Sleeping
Bear Dunes National
Lakeshore.

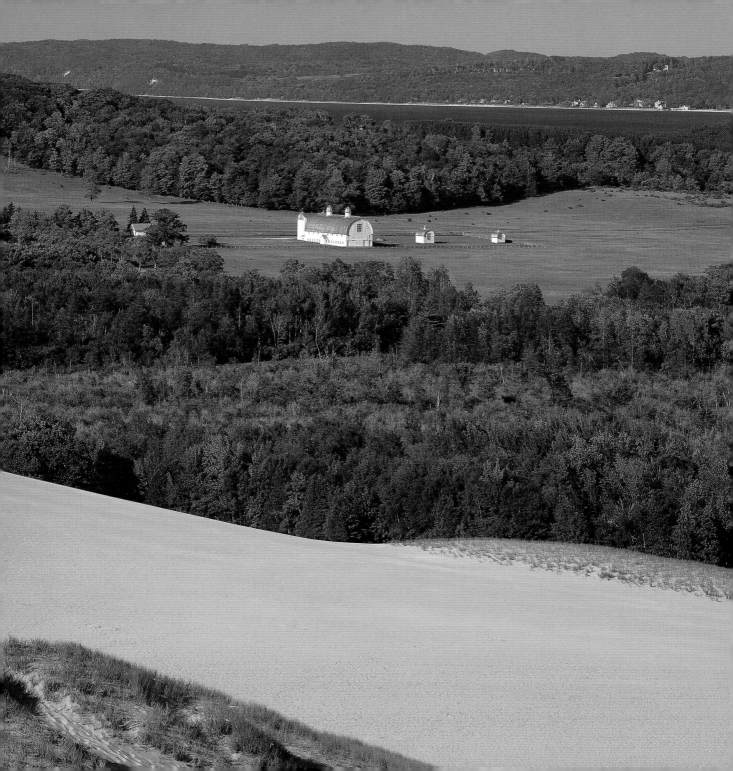

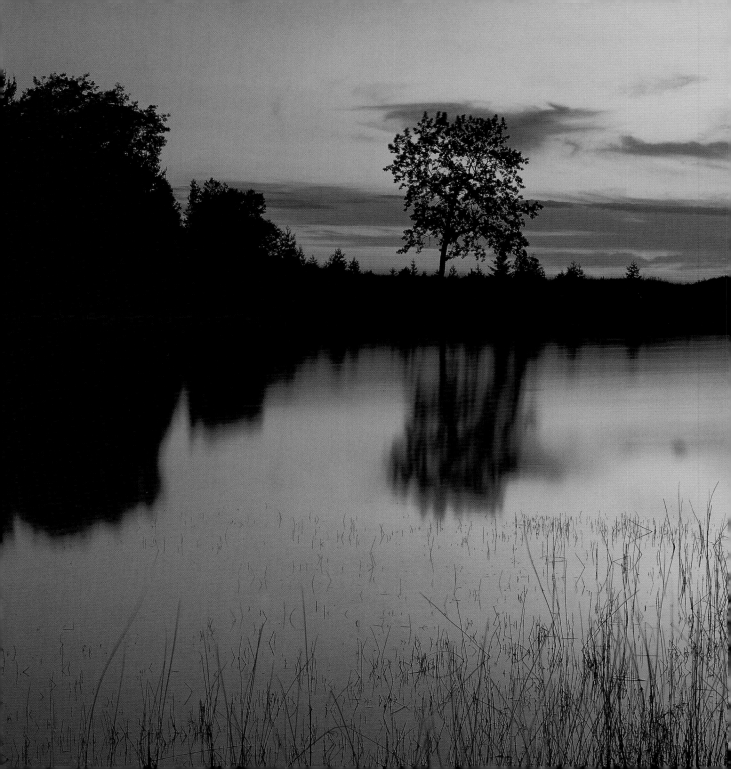

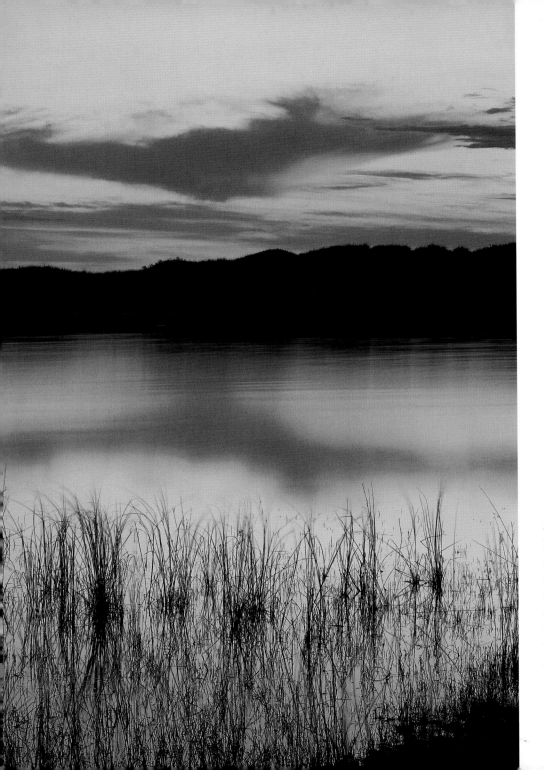

As well as protecting 200-foot dunes—some of the most spectacular of the 275,000 acres of dunes along Michigan's coastline—Sleeping Bear Dunes National Lakeshore preserves pristine forest stands and lakeshores.

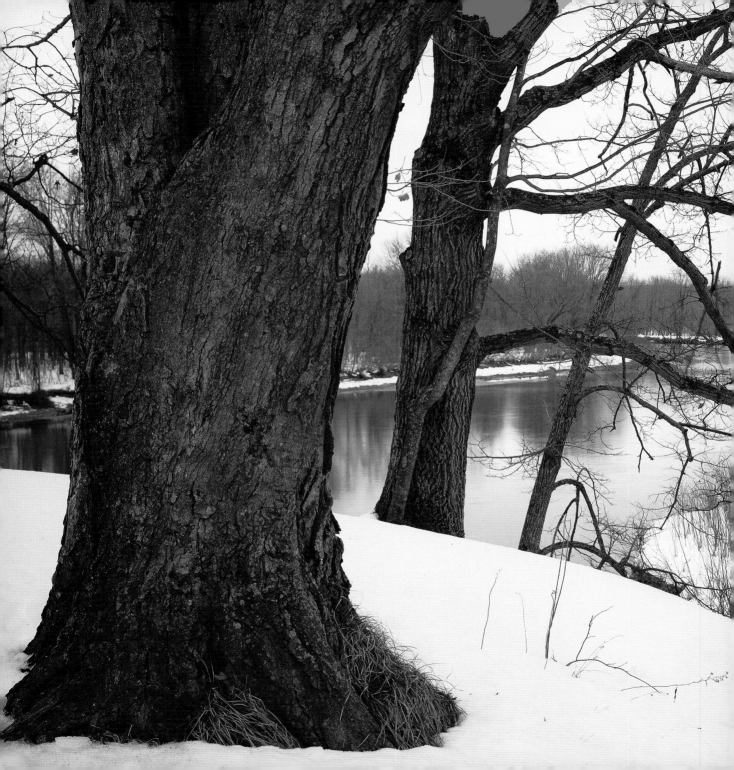

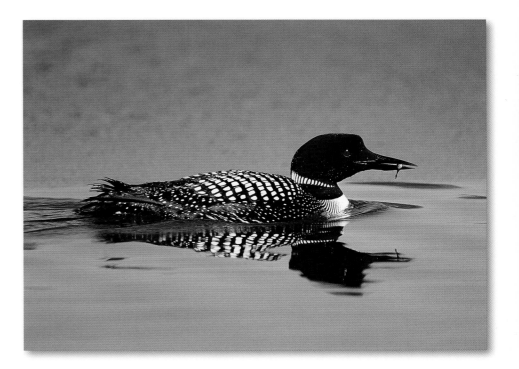

The reclusive common loon can still find a remote location to nest within the Huron-Manistee National Forest. There are about 20,000 loons in the states around the Great Lakes. These make up almost three-quarters of the loon population in the country, outside Alaska.

Once farms and lucrative timberlands, more than 964,000 acres in Michigan's Lower Peninsula are now encompassed by the Huron-Manistee National Forest. With 5,700 acres of wetlands, this area is also prime birding territory—enthusiasts often spot loons, woodpeckers, osprey, and eagles.

81

Muskegon State Park, one of 96 state-managed preserves, protects two miles of sandy beaches along Lake Michigan and another mile along Lake Muskegon. Hiking trails meander along the forested dunes between the two shores.

Cross-country skiing, ice skating, and ice fishing are just some of the winter sports enjoyed at Muskegon State Park. The park also boasts a luge run and some truly spectacular views.

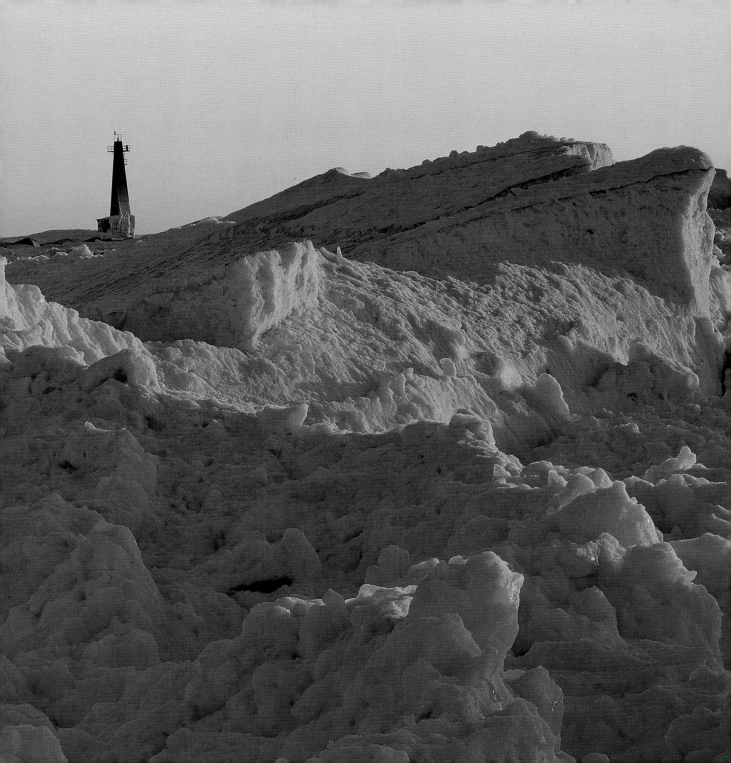

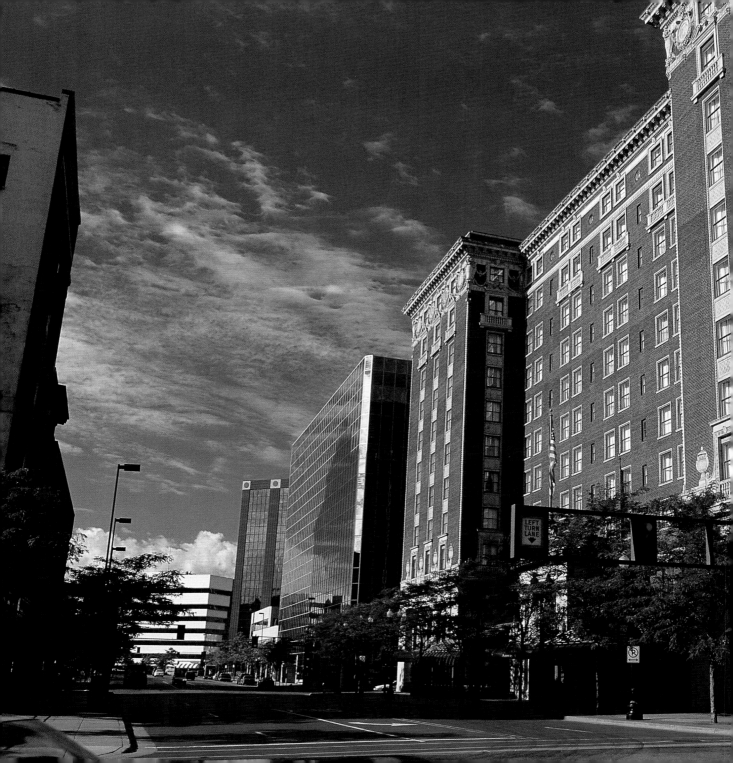

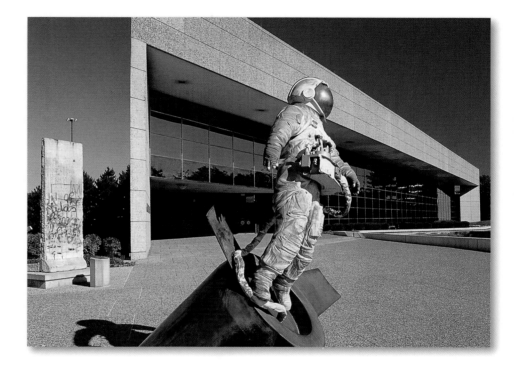

Part of the presidential library system, the Gerald R. Ford Museum in Grand Rapids allows an interactive view of the lives of the former president and Mrs. Ford. The museum holds several million documents, including letters and memos, the files of White House advisors, and campaign records.

French trader Louis Campau established a trading post in what is now Grand Rapids in 1826, and soon after the community was born. Since the late 1800s, Grand Rapids has been known for its fine furniture.

Grand Haven's boardwalk runs for more than two miles along the Grand Haven harbor, past shops, cafés, and galleries. Stray notes from waterfront concerts drift toward picnickers, and riverboat cruises depart nearby.

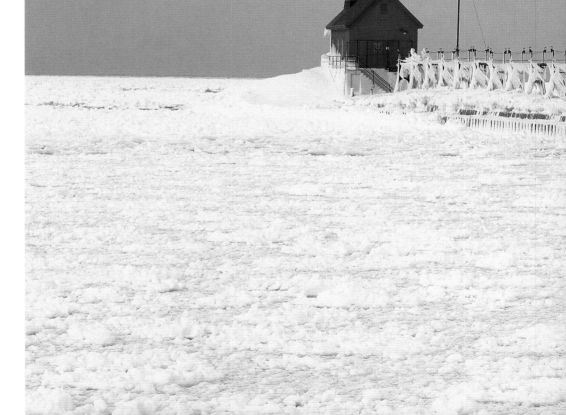

Beacons have shone from Grand Haven, at the mouth of the Grand River, since 1839. Today's inner tower, built in 1905, is connected to the smaller, 1922-built, outer tower by a long, lit catwalk.

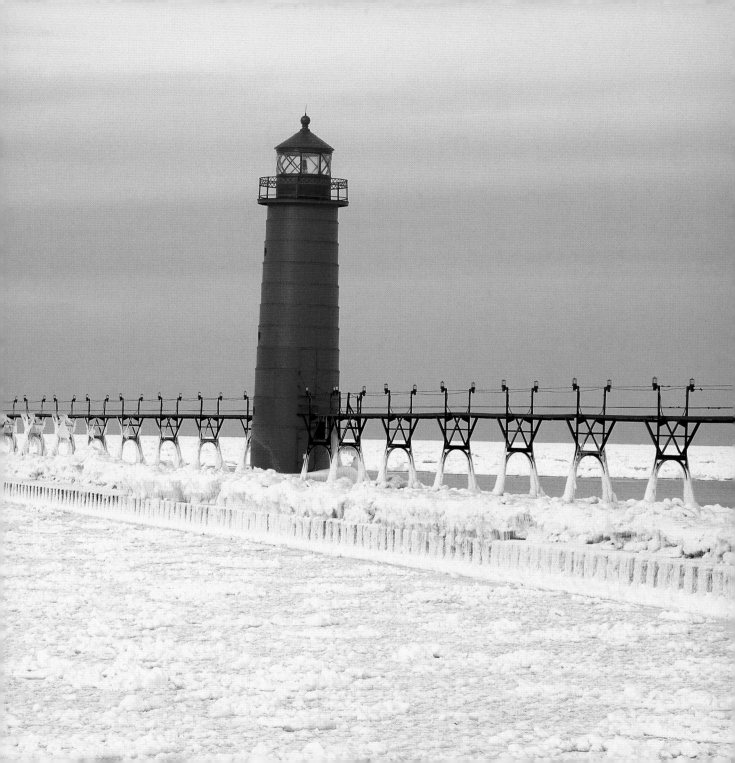

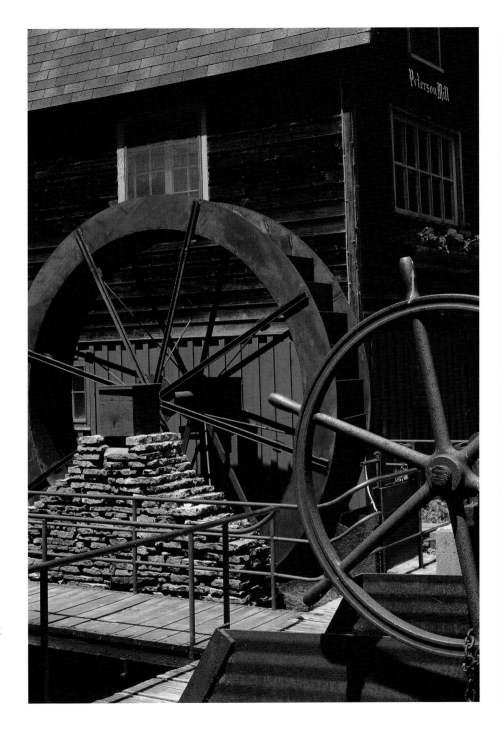

In the late 19th century, there were six sawmills in the Saugatuck-Douglas area, along with shingle and planing mills, a barrel factory, and ship-building sites. Today, the lumber barons of the past have gone, and the region is best known as a summer resort and artists' retreat.

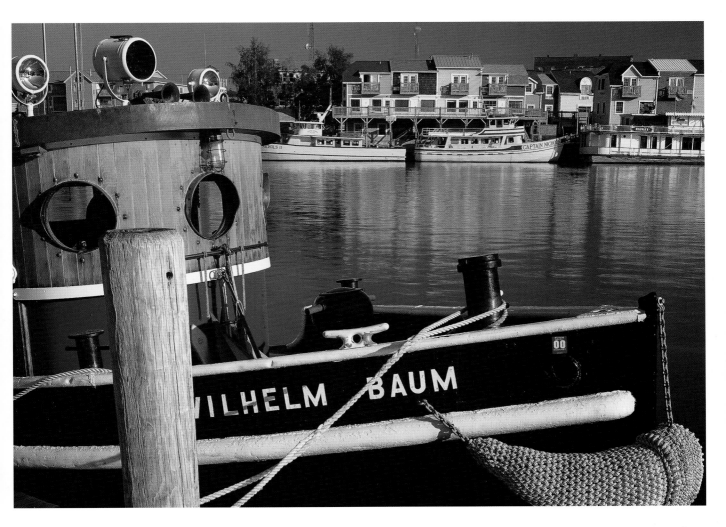

This restored 1929 tugboat is one of the sights inviting visitors to the Maritime Museum in South Haven. Here, exhibits commemorate the history of shipping on the Great Lakes, from storms and shipwrecks to coast guard rescue missions.

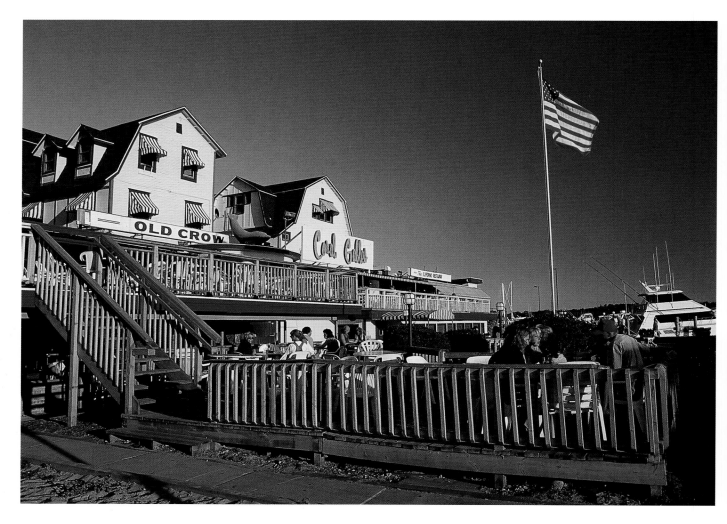

Kalamazoo was originally named Bronson after its founder, Titus Bronson. But after he was convicted of stealing a cherry tree, his name no longer seemed appropriate to represent the town. The new name, Kalamazoo, means "the rapids at the river crossing" in the language of the Potawatomi natives.

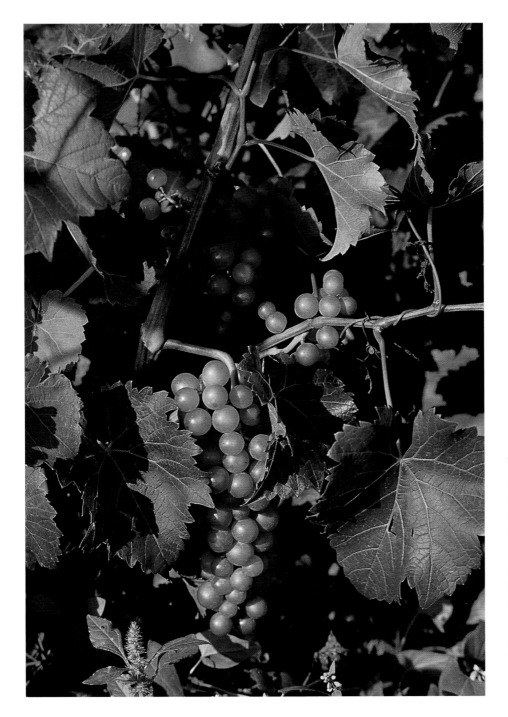

While vineyards in the north produce grapes for juice and jellies, those in the south, such as this one in Berrien County, serve the state's more than 65 wineries. Michigan is one of America's top ten wine producing states.

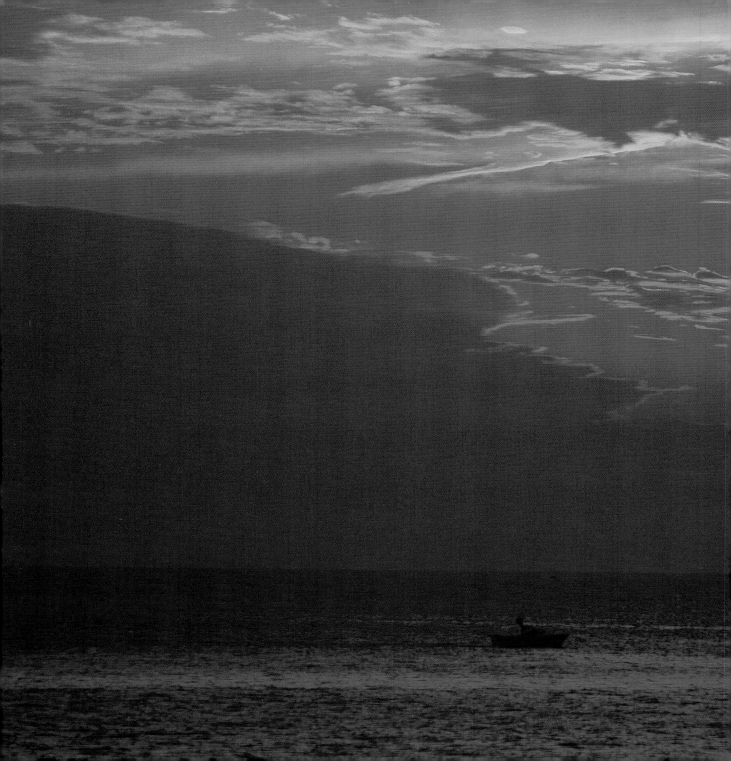

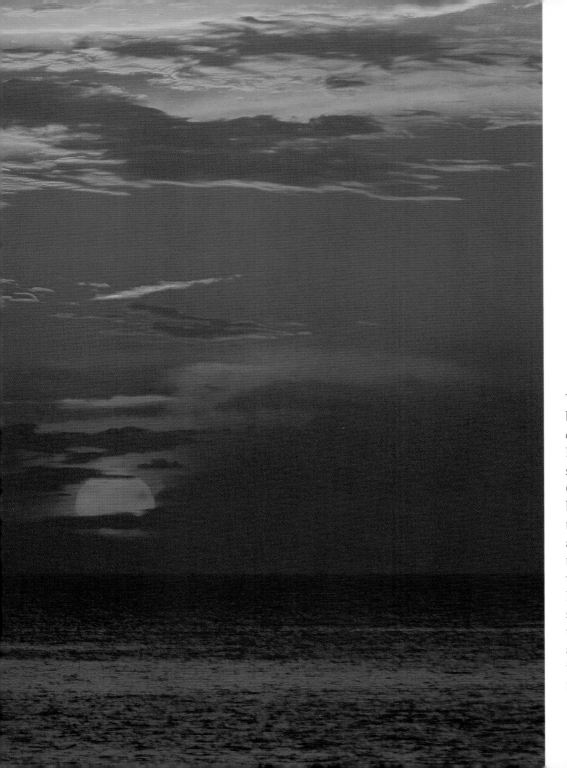

The setting sun breaks through the clouds over Lake Michigan, off the shores of Berrien County. Supported by thriving manufacturing, tourism, and agriculture industries, this southwestern corner of Michigan boasts a scenic coastline, varied communities, and more than 300 inland lakes and rivers.

Photo Credits

Bob Firth/First Light 1, 3, 29, 31, 46–47, 50–51, 52, 53, 54–55, 56, 58–59, 60, 61

Kord.com/First Light 6–7, 8

Richard Cummins/Folio, Inc. 10

W. Cody/First Light 9, 13, 32

Andre Jenny/Unicorn Stock Photos 11, 12, 24, 25, 35, 40, 41, 69, 84, 85, 86–87, 92

Grant Black/First Light 14–15

James P. Rowan 16, 18, 19, 36–37, 38–39

Kimberly Burnham/Unicorn Stock Photos 17

Chris Boylan/Unicorn Stock Photos 20–21

M. L. Dembinsky/Dembinsky Photo Assoc. 22–23

Ken Scott/Dembinsky Photo Assoc. 26, 27

Mary Liz Austin 28, 76–77

Skip Moody/Dembinsky Photo Assoc. 30

Terry Donnelly 33, 44, 45, 49, 63, 70–71, 72–73, 74, 78–79, 80, 82, 83, 88–89, 90, 91, 94–95

Mark E. Gibson/Dembinsky Photo Assoc. 34

Victoria Hurst/First Light 57

Steve Mulligan 42–43, 48

Thomas Kitchin/First Light 62

Morrow/First Light 64

Tom Till 65

David F. Wisse/Dembinsky Photo Assoc. 66–67

© Gordon R. Gainer/Dembinsky Photo Associates 68

Wayne Lynch 75

Aubrey Lang 81

Kitchin & Hurst/First Light 93s